THE FLOWERS

OF

EXETER

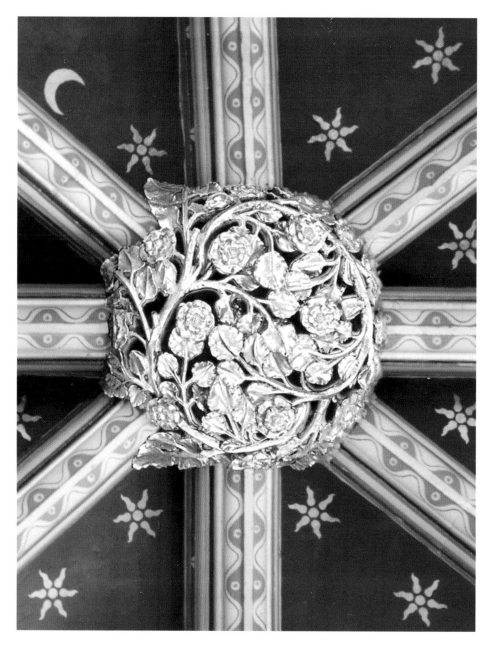

Boss 30. A Golden Rose without thorns on a ground of stars
and a crescent moon, all symbols of the Virgin Mary.

THE FLOWERS OF

EXETER

The ideas concealed within the decoration.

M.W.Tisdall.

Introducing an iconography
of foliage carving.

First published 2004 by
Charlesfort Press
23 Furzehatt Rd
Plymouth
PL9 8QX

British Library Cataloguing in Publication Data
A Catalogue record for this book is available from the British Library.

Front and back covers; the nave and bosses of Exeter Cathedral.

Edited by R.E.Aldridge.
Printed by E.J.Rickard, Printers,
11-13 Holborn St, Cattedown, Plymouth. PL4 0NN

ISBN 0 9532652 1 8 Hardback
ISBN 0 9532652 2 6 Paperback

ACKNOWLEDGEMENTS

An early interest in wild flowers, encouraged by my Mother, sets the basic scene. My uncle, Prof. Sir E.R.Leach, an anthropologist and humanist, wrote analyses of several Biblical episodes. He provides novel insights into some matters that are usually considered too difficult to address confidently.

I asked a friend, Dr Alison Watt, to help with identification. She and her associates of the botanical section of the Devon Association have provided invaluable assistance, and to them I am most grateful.

Dr Celia Fisher, an acquaintance and expert on Marian iconography - especially where flowers are concerned - has been most kind and encouraging and I wish to thank her warmly.

Keith Barker, of the Cathedral guides, has been a kind and generous contact and I am most appreciative of all the help he has given.

I should also like to thank Prof. M. Swanton, who very kindly went through a draft script and made many helpful suggestions.

Finally, I should like to thank the Dean and Chapter, who permit all of us to visit and absorb the beauties of the cathedral.

The picture of Diana on p.33, presenting Artemisia to Chiron, is by permission of The British Library, and is from Harley 5294. f.14.

All other photographs are by the author.

INTRODUCTION

"To transmit the things of God and the Spirit by means of corporeal similitudes is advantageous."

"For one thing may have similitude to many; for which reason it is impossible to proceed from any thing mentioned in scripture to an unambiguous meaning."

"The most hidden things are the sweetest."

St Thomas Aquinas.

Exeter is fortunate to have a particularly good selection of accurate foliage carving. This little book is an introduction to the flowers, foliage and some of the animals that might intrigue any visitor. It is my hope that when one understands the underlying significance, an appreciation of their beauty will be greatly enhanced. This knowledge may then quicken an interest on a visit to other churches and cathedrals. Though mainly about flowers, I have included a few animals and humans where new ideas in the literature throw a fresh light on hitherto unexplained subjects.

The Introduction should help to put the carving in the context of the time. Any such effort is going to be highly selective and subjective. My hope is that the aspects chosen will be of interest, and even novel, to some readers.

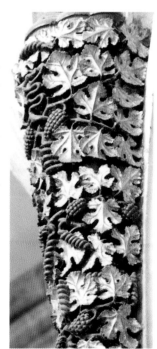

Corbel B. Vine & Grapes.

Some cathedrals, such as Chartres and Notre Dame in Paris, were built very much to honour the Virgin Mary. Mary, who has as one of her many symbols an enclosed garden, deserved to see the flowers of her garden in this special place that belonged to her. The entire flora was dedicated to Mary but some flowers had an especial association and the common English names reflect this: (Our) Lady's Mantle, (Our) Lady's Bedstraw, (Our) Lady's Smock, (Our) Lady's Slipper; the list is almost endless. The Lady Chapel of this and other contemporary cathedrals contains a wealth of flower forms. They were not chosen for their striking appearance, though the carver utilised this to best effect. Instead they tell us and, in those days were thought to remind Mary, of her special place in the worship of the Church. They also carry many other messages.

The Lady Chapel, Ambulatory and Presbytery at Exeter were built in the decades 1279 – 1307. The desire to carve naturalistically seems to have started at Chartres in the great rebuild following the fire of 1194. The clearest flower forms are in the North Portal, 1230. In that fire it was feared that the deeply venerated relic, the chemise that Mary wore at the Annunciation, was lost. When it was found to be intact there was great rejoicing and it was taken to be an indication from Mary herself that an even better Cathedral should be built.

5

The northern doorway of the west front of Notre Dame, Paris 1200-1220, has a clear demonstration of flowers particularly related to Mary. The exiting streams of visitors pay no attention but it is worth a moment's pause to examine them. They include olive, pear, oak and vine on one side, and rose, ivy and artemisia (mugwort) on the other.

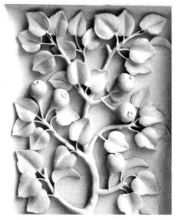

Notre Dame. Paris. Pear.

The cathedral at Reims has an excellent collection on the inner side of the west façade, carved about 1260, also following a major fire. There the individual species are paired with particular individuals from the Bible. It is fascinating to find that the same 'meaning' is to be found at Exeter, even though at Exeter there are no Biblical individuals to see.

The Catholic Church was a great unifier of Western Europe by using one language - Latin - for its services and with a liturgy that was essentially the same throughout. It could commission new projects and had enough money to see them through. It could specify the details of geometry, glazing, carving and painting and moreover it could do so in the context of giving glory to God.

There is a dictum attributed to St Gregory that images serve for three things:-

(1) To stir men's minds to think on Christ's incarnation and on his passion etc.
(2) To stir men's affection and heart to devotion; for often men are more stirred by sight than by hearing or reading.
(3) They be ordained as a token and a book to the common people, that they may read in imagery and painting that which clerks read in books.

Visual images come in three forms; wall paintings, stained glass and carvings.
Wall paintings have virtually disappeared from our churches, those that remain testify to their probably virtually universal use to instruct the unlettered.

Stained glass, though it has been said to be a picture book for the poor, is often extremely difficult to decipher. The clear and close pictures can be both inspirational and a teaching medium. The more distant are perhaps better seen as a metaphors. The light is transformed into jewels by the glass. It is light of the New Life – the *opus modernum*- of Christ.[59] In some instances one of the concerns seems to be an acknowledgement of the name and status of the donor, be it an individual or guild.

Architectural design was based on Geometry, the king of the mathematical sciences. God was the great architect and Geometer. Each number had a sacred significance and while we cannot see the numbers built into the design of a medieval cathedral, God would appreciate it.

There is so much carving in religious contexts, that we have become inured to the beauty that the carver laboured so hard to express. We have also become inured to the emphasis on "beauty" while remaining ignorant of the other messages in the carving, and to which we can only attain by savouring a variety of associations.

It has been said that everything about a Gothic church was moralised, that is inspired with some sort of spiritual significance.[11, 13] The great roof bosses of our cathedrals often carry a story such as the Crucifixion, the Coronation of the Virgin, the four evangelists, and many versions of the battle between good and evil, etc. These are relatively easy to understand. It may be less easy to understand the significance of animals such as the Lion and Dragon, or

Eagle and Hares unless one is primed with their stories. The foliage bosses are usually ignored and dismissed as purely decorative. It is possible however to find that they provide a wealth of associations to stories that were well known at the time. They do not teach, rather they act as triggers to the memory to give colour to the spiritual life.

At a slightly later time than the carving here pictures of the Virgin include flowers that are consistently the same. It is possible therefore to deduce their likely significance. Carving has not enjoyed the attention that the pictures have received and the meaning is consequently farther from our understanding. We know that the vine carries a message and has done since vines appeared on the walls of the catacombs. "I am the true vine, you are the branches" Jn.15 v 5. The vine is Christ with the natural corollary that the grapes that become wine tell us of the wine of communion and the blood of Christ.

If the vine meant so much, then it is hard to believe that the other plants that put in a frequent appearance have no significance. It is interesting that the plants they selected are similar across England and to a great degree Northern Europe implying that the carvers or their patrons wished to present a consistent message. Oak, ivy, hawthorn and maple are just a few of the most abundant in church carving. Some have postulated that the carver made a random selection from field and hedgerow, stuck them in a beaker and copied them. They may have used local sources for some of their models but others do not occur where we find the carving and there must be a more significant reason than mere chance for their appearance.

Animal carvings rarely use the local fauna; deer, fox, hares and owls are almost the only ones. Most of the others are exotic; elephants, lions, tigers, salamanders, griffins, wyverns, ibis and pelicans to name but a few. These animals have stories that were well known to the clergy and, via them, to the populace at large. Animal carvings derive mostly from pictures in the Bestiary, a collection of lessons based on animal descriptions. Theological thinking had proposed that animals were there for our Instruction and Enjoyment. So a book about animals, such as the Bestiary, was essentially a book of moral lessons rather than a descriptive natural history [4.69.74]. Tigers warn us to beware the bright distractions of this world. The Pelican is more than the commonly quoted "symbol of the Eucharist". The story is a parable of man's sin, punishment and redemption. It will become apparent that plants carry analogous powerful stories but much more diffusely. Where an animal 'means' between two and five different things, plants can mean, i.e. be associated with, dozens of ideas.

Mary's purity is reflected in the whiteness of the Madonna lily. Columbine or Aquilegia acquires its names from the little florets that they likened to doves, *columba* or eagles, *aquila*. The dove idea makes for an immediate association to the Holy Spirit descending in the form of a dove at Jesus' baptism. As has been said by authorities such as M. Camille, "Nothing is ever just decoration, especially in Gothic art, although such objects continue to be classified as such."[11 13] Flowers provide a backdrop of potential associations that can be accessed at leisure. The themes will be new to many but they are widely dispersed in the literature and have been collected here to show the range of thinking demonstrated by our medieval ancestors. The really new ideas are those relating to mulberry, white bryony, maple, hop and broom.

Some people say, and none more charmingly than E. Mâle [51 p54], "that artists, though under supervision when charged to express the religious thought of their day, happily for us were left to decorate the churches with innocent flowers at will." That statement has influenced opinion in this area for a hundred years. Others however have pointed out that the relatively sudden and widespread appearance of recognisable species must be based on a

coherent code of theological thought.[8] Decoration for its own sake is not a sufficient explanation for the nature and arrangement of the species portrayed. A brief glance at the roof bosses shows that there are proper places for the major themes. Christ is above the altar at the East End. The Virgin is crowned above the altar in the Presbytery. At another significant point, the centre of the Lady Chapel, there is pure foliage. This choice is not a random one but follows a plan. Some of the most magnificent bosses are at such positions and the aim of this book is to suggest possible reasons for their presence in just those places.

The medieval world-view was very different to ours. Our times are suffused by the protestant ethic, the scientific method, evolution and authority lying not in texts but in theories susceptible to proof.

For them the sun revolved around an earth that was the centre of the universe. The planets moved on transparent spheres with an outer sphere of stars, and the whole kept in motion by a Prime Mover or *Primum Mobile*. The whole apparatus made a 'heavenly harmony' as it moved.

Their authority was the Church, with a Bible in Latin, and so accessible only to the scholarly. The great doctors of the Church and other commentators and preachers were held in high regard; the more ancient the greater the regard. Only scholars and the priesthood could read, and even fewer write. To 'read' for the upper and middle classes was to be read to. One did not scan a page silently; rather one listened, savoured, and maybe repeated, every word and phrase. So the Bible, the stories and the Psalter were known in a more intimate way than we might do. We tend to know *about* things where they might know things intimately. When they 'read' a carving they savoured, explored and delighted in the rich associations that would be available.

Books were hand-copied, in short supply and not readily available. The great intellects were praised most for their memory.[13] Books were few so one needed a well-stocked memory to furnish the associations. Noviciates to a life in the Church would start by learning all one hundred and fifty psalms - in Latin of course. Ever after, a phrase or a verse would be instantly recognisable and one should be able to proceed backwards or forwards thereby gaining immeasurably from the rich associations. The very bright such as the learned Doctors and the more studious would know most of the Bible, commentaries on the Bible, the papal pronouncements, and no doubt a whole tranche of civil law as well. Such a feat requires a trained memory and many were the techniques described to help. In one such it was suggested that one could imagine an Ark. It would have many decks, many cabins on each deck and varieties of furnishings in each cabin. Cabin 1 might store those words beginning with 'A'. Cabin 2 is organised totally differently, say those herbs that stopped bleeding. Cabin 3, say the seven virtues and the seven vices and all other 'seven' collections. Everyone would have their own scheme, indeed it was essential that they did so, but the result might be that items become classed together that we would never find had anything in common.

The "Doctrine of Signatures" of medieval medicine worked on this principle. Herbs that look like a specific part of the body were obviously designed by the Almighty to heal that part. Lungwort-*Pulmonaria* - has speckled leaves that look like the cut surface of a lung, and so was used for chest infections. Lesser Celandine has roots that look like piles, so *Pilewort,* and was used to make a soothing ointment for that part. The details are not important for us but the principle on which their minds worked is. The point for our discussion is that items we might not put together with our more analytic approach could well find themselves associated by just sounding alike or looking alike but not necessarily being alike at all.

They delighted in verbal and visual puns, or rebuses. One finds evidence in the numerous puns on names in most cathedral carving. At Exeter bishop Oldham's chapel has a plethora of owls – Bishop 'Owldham'. Puns, as is shown below, carried a weight far beyond the merely intriguing. It was as if God had made the words for each other.

This apparent digression is relevant to the story for one finds that foliage carvings have a meaning by virtue of their associations rather than by direct translation. An analogy with music is helpful. One cannot ask what a piece of music means, it only means something by association. One's own national anthem is full of emotional associations. To most of us that of a distant land is a total blank. So it is with these carvings. The clergy spent many hours a day in this area where thoughts and ideas could resonate with a carving. Lateral thinking, to link with other items in the same locality in one's memory, would provide many positive spiritual benefits.

In this cathedral as in many others, creatures, usually dragon-like, appear to bite their own wings. This is the same action that birds use to preen, and the action becomes intelligible when viewed in this way. To preen is to renew, make straight, make healthy or rejuvenate. Animals doing this provide a metaphor for the change and opportunity provided by the Christian life.

There are several references to the Bestiary. This was an extremely popular illustrated collection of stories about animals, each having several significant stories attached to it. The stories were used to make simple, clear, moral points in the teaching of the masses.

The Virgin Mary was at the peak of her honour and adoration. Her veneration had been increasing dramatically since the time that it started in the 6th century. Several cathedrals and hundreds, probably thousands, of parish churches are dedicated to her. She is closely associated with this one. At a popular, human family level, Mary was the Mother to whom we could all relate. Christ was portrayed in more distant terms; Christ the Judge, Christ in Glory, whereas Mary was perceived as being a reliable intermediary between Him and us. Honour done to Mary in this world, however simple it might be, would be sure to stand one in good stead when it came to asking for her help on Judgement day. Stories abound as to the certainty of this fact. One such, alluded to in carvings in several places, is that about Theophilus who sold his soul to the Devil but, with Mary's help, managed to redeem it.[51] Another, pictured at Exeter on a nave corbel, alludes to the story of the Virgin Mary's tumbler. He had entered a monastery but his only skill was that of a fair ground acrobat. So he performed secretly in front of a statue of the Virgin. This was as a demonstration of the gift of his talents to her.

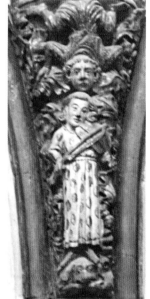

Nave Corbel K[1]
Our Lady's tumbler

There were hundreds of stories about Mary; some came from the Apocryphal Gospels,[44] and others from the Golden Legend.[70] Yet others accumulated over the years from local episodes in which she was said to have had a hand.

The Golden Legend is essentially a collection of stories, mostly about saints, from the second to the thirteenth centuries. Jacobus de Voragine collected them in about 1260. He left them when he died, as a collection of *Readings on the Saints*. It was so popular that it soon became known as the Golden Legend and was read all over Europe.

The Apocryphal Gospels, a New Testament collection of early Christian writings that never made it into the canon, were nevertheless extremely popular. For instance they contain the story of the Harrowing of Hell. Christ descends into Hell on Good Friday, breaks the chains and bursts the doors, binds Satan and returns on Easter day leading out Adam and all that had died before Christ's time. There are several animal metaphors of this. Samson rending the lion's jaw is a favourite and appears at least twice on the main roof bosses. It was a vivid way of expanding the phrase "He descended into Hell and on the third day rose again." The Apocryphal Gospels also tell one about Mary's mother and father, and are the prime source for the story of Mary's Immaculate Conception. They also detail how she came to be chosen as Joseph's wife. They tell one of the hazardous journey into Egypt, and the miracles that occurred there. It should not be a surprise to find that some of the bosses in the Lady Chapel allude to these episodes.

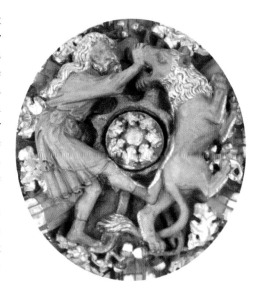

Boss 67. Samson & Lion.

Mary was supreme in the average person's affections and a major part of the flora was dedicated to her. It will be seen that the botany dovetails with the spiritual requirements of the time, to create an iconography that rings true for Exeter.

My primary sources are the carvings themselves and the secondary sources are listed in and referred to, in the Bibliography. There are some excellent books about the Exeter carvings, and a very good web-site.[39] They include works by C.J.P.Cave,[14] E.K.Prideaux and G.R.Holt Shafto,[63] and Prof. Michael Swanton.[68] Nikolaus Pevsner wrote a study on the Leaves of Southwell [62] and provides notes to Cave's book about Exeter. C.J.P.Cave could not discern more than a random order for Exeter, and N.Pevsner felt that the spirit of the age was enough to imbue the carvers at Southwell with their undoubted ability to transform the green of the wood and hedgerow into items of great beauty. Denise Jalabert [43] in France, and Lottlisa Behling [8] in Germany have written extensively on foliage sculpture. Indeed there is much more written on this subject on the continent than here. L.Behling is particularly good on the evolution of carving styles but does admit that the English evolved their own "idiosyncratic" forms.

Exeter has good financial accounts for the time but I am not aware of minutes of meetings of the Cathedral chapter, where thoughts on an iconography might have been rehearsed. It would be rare to find them for even a modern project.

The lyrics, hymns and secular songs of the time almost certainly provide material relevant to this sort of study. I have found some but have only skimmed the subject.

The famous scholar/mystics such as Hildegard v. Bingen, theologians such as St Bernard of Clairvaux and Albertus Magnus, as well as collectors of knowledge such as Isidore of Seville, also provide much of the input.

I have also added an explanation for some of the other bosses that engage the attention and that have lacked explanation in the current easily available literature. My attention is focussed on the East End, for that is the area of reasonably accurate carving. There are many other interesting bosses and corbels in the remainder of the cathedral but to detail them all would be to repeat what others have said and move away from the primary purpose here of highlighting the fascinating story to be found in the flowers and leaves.

Exeter, begun in 1279 or thereabouts, was a replacement for a Romanesque cathedral whose towers remain. The code by which one read a church was well established. The east was holier and nearer to Jerusalem than the west. The roof could be viewed as an aspect of heaven or, for Mary, a paradise garden. Doorways marked significant and important boundaries.

At the East End is the Lady Chapel, dedicated to the Virgin Mary, and the first place to be built. The story continues into the ambulatory and the Presbytery, and only changes in the choir, where a new ethos inspires the agenda. There is much detailed beautiful foliage and rather than it being a random collection of skilful carving, I hope to show that there is a definite iconographic program. This is not more boring Gothic decoration. Instead it is a reminder of many items in the foundations of the Christian faith.

Herb Paris. See p 54.

Comfrey leaf.
See p 25.

East

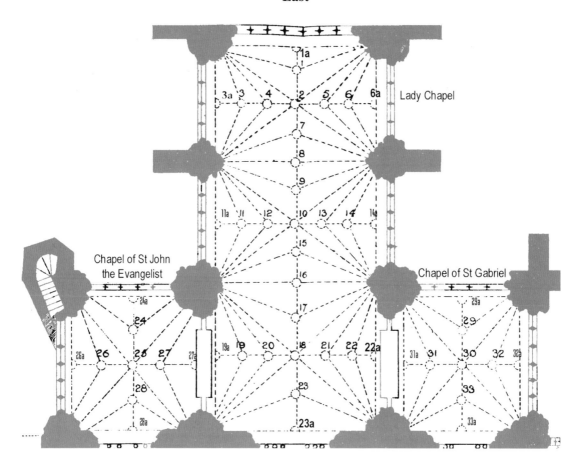

THE BOSSES AND CORBELS

The numbering on this and the later plan is a guide to the positions of the bosses mentioned in the text. Numbering follows the numbering in the web-site, [39] which itself is based on the numbering in Prideaux and Shafto.[63] Half-bosses are numbered according to the nearest full boss; e.g. 43a. Where I mention botanical colleagues they are (1) Celia Fisher,[23] (2) Dr Alison Watt and her colleagues in the botanical section of the Devonshire Association. Their advice has been invaluable.

"Ave Maria gratia plena"
"Hail Mary full of *grace*"

Every child would have learnt his Paternoster (Our Father) and Ave Maria (Hail Mary) as the minimal demand made by the Church upon the peasant population. Grace would be a familiar term, and it will be seen that '*grace*' is an important feature of the spiritual message in the carvings above us. In a Church context, *Grace* means an *undeserved* benefit given by God.

The Lady Chapel is the obvious place to begin. It is dedicated to the Virgin in a cathedral dedicated to St Peter but with a special reverence to the Virgin, and is at the most easterly end and so nearest the heavenly Jerusalem.

Boss 1a.

This is **White Bryony**. On the web-site it is named as grapes but it has the same characteristics as Boss 14 and Corbel C. It is entirely appropriate that it should be here, which will become obvious when we discuss white bryony at Boss 14.p 23.

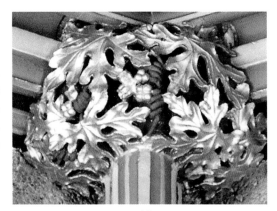

Boss 1a. White Bryony.

Boss 1.

The eagle of St John joins the other evangelistic symbols: the Bull, Boss 5, the Lion, Boss 4, and the winged Man, St Matthew, Boss 7, around the garlanded head of Christ, Boss 2.

The white bell flowers are labelled as lilies on the web site. It is difficult to think of any lilies with this flower shape. The flowers look like bluebells or possibly harebells. They also resemble the three-cornered leek, *Allium triquetrum* and the summer snowflake *Leucojum aestivum*. The leaves are nearly those on harebell stems. White forms of bluebell do appear occasionally in nature and one can guess that they would be especially earmarked for the Virgin Mary. White harebells probably exist but I have not seen one. The Bluebell is the wild hyacinth, *Endymion non-scriptus*. To the peoples of Greece and Rome, Hyacinth meant what we now call *Hyacinthus orientalis*. It is the forerunner of our big garden hyacinths. It looked similar to our bluebell but without the drooping head. Their hyacinth had, they thought, a mark on the petals that spelt AI, (Alas). This referred to the Greek myth of Hyacinth's inadvertent death at the hands of Apollo. Our hyacinth does not have this mark so is referred to as '*non-scriptus*'. Some of Apollo's attributes such as Prudence and Wisdom seeped into

Christianity making the hyacinth a symbol for Prudence and Wisdom.[52] Prophets shone for their faith just as this flower shines with a beautiful colour. Honorarius of Autun.[52]

In much later Renaissance paintings we find hyacinths as a symbol of Christ. In the Song of Songs (Vulg) 5 v 14; it says, "His hands are turned as of gold, full of **hyacinths**, his belly as of ivory, set with sapphires." The Song of Songs had long been extolled by St Bernard of Clairvaux as a metaphor for the love of Mary and in spite of its very erotic language, had been seen in a largely spiritual light.

Summer snowflake and Lily of the Valley were used in later painting and tapestry as Mary flowers.

The true harebell, *Campanula rotundifolia,* had the name 'Our Lady's Thimble' because she used one to protect her finger after pricking it while sewing.[48] The Hare has immediate associations with the Virgin because it was considered able to conceive without male help.

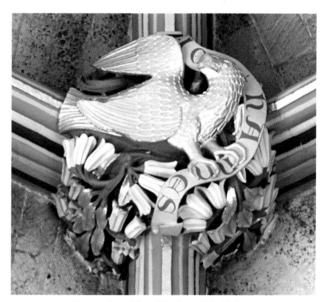

Boss 1. The Eagle of St John.

I do not know of a direct connection to St John for either bluebells or harebells or lilies. Christ, speaking from the Cross, asked John and Mary to care for each other. This may reflect that particular relationship. Jn.19 v 26-27.

Thomas the Cistercian is said to have seen the hyacinth as a sign of *grace.*[52]

At the beginning of St John's gospel John the Baptist states that *grace* and truth came by Jesus Christ. Jn.1 v 17. In Mary's genealogy we shall find much more evidence for the action of *grace.*

Boss 2. 'Pastor Bonus'.

In prime position above the altar is the head of Christ as the Good Shepherd.

He wears the slightly worried expression that one finds in many 'Green Man' carvings not only in this cathedral but also widely in England. He has a circlet of **rose leaves and flowers**. The rose is primarily a Marian flower but it has innumerable other associations that I shall discuss all too briefly.

In antiquity the rose was the queen of flowers, a favourite for the crowns that acted as a reward for poets at banquets. Here it is a crown. The crown of thorns was a parody of this crown of honour. It is the flower of Venus and appeared on land as Venus arose from the sea. So, ever after, it represented triumphant love. Adonis was killed by a boar, and while Venus was trying to reach him the white rose became stained with his blood. So one association for a red rose is that of death and hence martyrdom.

The sweetbrier, our English five petal rose, was an attribute of Christ because the five petals were a reminder of the five wounds of Christ on the cross. It was also to become an emblem of the Five Joyful Mysteries of Mary and the five letters of her name, Maria.

There was too an ancient Catholic custom dating back to St Gregory, (540 – 604 AD); of the sending of a golden rose by the pope to people of distinction, as a symbol of special papal benediction. The Golden Rose is supposed to have acquired its colour from Christ himself when He died on the cross. This appears in a 12th C. poem.[52]

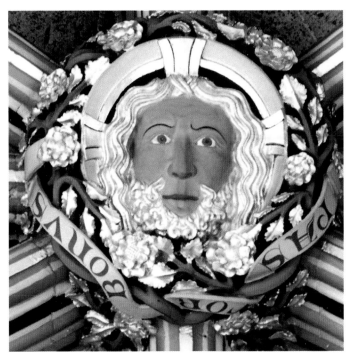

Boss 2. The Good Shepherd.

St Ambrose in the fourth century declared the rose to be the most perfect of flowers, that when in Paradise, had no thorns, for the flower contained no deceit. After the Fall the rose developed thorns in order to remind man with its fragrance and beauty, of Paradise, but with the thorns, of the sin of man.

The Virgin became the rose without thorns because she was the only human being known to be exempt from original sin and its consequences; The Virgin Immaculate.

Where the Bible says "I am the rose of Sharon, I am the flower of the field" in Song of Songs 2 v 1, and in Ecclesiasticus 24 v 18. "I was exalted like a palm tree in Cades, and as a rose plant in Jericho," the "I" was seen as Mary.[52] The rose of Sharon thus acquired a secondary meaning: that of incorruption. The roses round Christ's head may represent that rose.[63]

During the 6th century, when the Church instituted the cult of the Virgin, the rose became the flower of the tribe of David, from which Mary and her Son descended. In the 7th century Mary was known as Rosa Mystica in recognition of the mysterious generation of Christ from her womb.[48] According to the Christian poets: "Mary's motherhood enclosed the whole of earth and heaven within her womb, within the space of a single round rose."[30] When Mary was laid in her tomb, "she was straightway surrounded by red roses signifying the army of martyrs."[70] 'Doubting' Thomas, who was a late arrival at Mary's funeral, refused to believe that she had ascended to heaven, and demanded that the coffin be opened. He found it full of roses and lilies. Looking up he saw Mary and she threw down her girdle to him.

There are some Latin hymns for the nativity in which Christ is referred to as the rose springing from the lily. The rose is not often used as a symbol for Jesus Christ but is used as a symbol of His love. In the Speculum Humanae Salvationis (14th C.) the rose represents Christ as the perfect flower of the human race.[37]

The Church prays: 'Rosa Mystica, ora pro nobis,' referring to the Virgin Mary.

A hymn circa 1300, speaks of Mary as the rose without thorns that bore heaven's king.

> 'Lady flower of alle thing
> Rosa sine spina
> Thou barist Jesus, heavene king
> Gratia divina.'

There was also at this time a rich secular tradition associating the rose with love, and there was a long French poem, The Romance of the Rose, an allegory on the Art of Love.

Another secular association is the rose in a rose ceiling. This dates back to ancient Greece where a rose suspended over the dinner table enjoins those present to treat all conversation as secret -'sub rosa'.

The Rosary was not yet the universal aid to devotion that it was soon to become. However a popular legend describes how the words of the salutation, " Hail Mary full of grace, etc", are transformed into roses that form a garland, or chaplet for the Virgin. The practice of weaving symbolic chaplets, or wreaths, of verbal roses as gifts to Mary became a favourite gesture of devotion. The term Rosenkranz, or rose garland, becomes the Rosary.[73]

In the 16th Century a large double rose appears frequently in church carving. It is often referred to as a 'Tudor' rose. This may be correct in many instances but it may often refer to Mary whose worship had permeated every aspect of Church thought, and about whom reminders flourished at every turn.

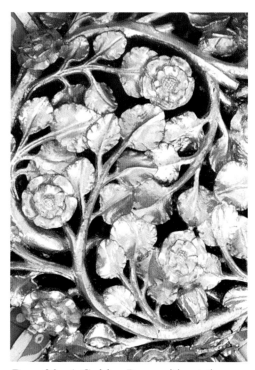

Boss 30. A Golden Rose without thorns.

It is impossible in a short space to evoke the aura that surrounds the concept -'Rose'- but that it is rich and complex, and deeply emotive, is in no doubt at all.

For the many other rose carvings that one will see, please refer back to here for likely associations.

Boss 8. Vine leaves and grapes.

The vine is ubiquitous in church carving. One meets it everywhere, on screens, lecterns, pulpits, bench ends, capitals; in fact almost any surface that needs a bit of enrichment seems to acquire a vine leaf. Vines appeared as a symbol of Christ in catacomb art and have never looked back. Christ Himself said: "I am the vine and you are the branches." Jn. 15 v 8. The vine produces grapes from which we make wine, and it is wine that becomes the blood of Christ in the Catholic doctrine of transubstantiation.

The Tree of Jesse, that representation of the genealogy of Mary, or sometimes Christ, shows coils of a vine springing from Jesse's loins and in the coils lodge members of the House of David.

Another, less happy, association of the vine is in Rev.14 v 18. The angel thrust in his sickle and gathered the vine of the earth and cast it into the great winepress of the wrath of God; very much a Last Judgement episode. We only meet this aspect in some Norman / Romanesque carvings. Such occur at the west door of Leominster (Herefs) and inside Castor church (Cambs).

The vine is a symbol of peace and prosperity: Micah 4 v 3-4. "and they shall beat their swords into ploughshares, and their spears into pruning hooks, nation shall not lift up a sword against nation, neither shall they learn war any more. But they shall sit every man under his *vine* and under his fig tree and none shall make them afraid, for the mouth of the Lord of Hosts has spoken it."

Grapes were one of the fruits of the Promised Land. The spies sent to investigate Canaan came back with an enormous bunch of grapes across the brook Eschol. Numb.13 v 23. They also came back with pomegranates and figs. All three appear in art as symbols for the rewards of the Christian life.

Boss 8. Vine leaves and grapes.

The vine can also refer to the vineyard as a protected place, where the children of God flourish under His care. "For the vineyard of the Lord of Hosts is the House of Israel, and the men of Judah his pleasant plant." Is. 5 v 7. Hence the vine can be used as a symbol for the Church in whom this relationship exists.

The vine can also be a symbol for the Virgin Mary. Ecclesiasticus 24 v 17 or 23 (Apoc. or Vulgate.) "As the vine I have brought forth a pleasant odour, and my flowers are the fruit of honour and riches."

Mary was the vine that sprouted from St Anne, and blossomed into sweet grapes that brought eternal life to mankind. (St John Damascene.[52])Mary was the vine of grace that gave wine of joy.(Edmund of Canterbury. 1175 – 1240.AD.[52])

The vine was a symbol of the Church as stated by St Ambrose. (339-397 AD) Ps.80 v 8. "Thou hast brought a vine out of Egypt: thou hast cast out the heathen and planted it," also: Is.5 v 1. "Now I will sing to my well-beloved a song of my beloved touching his vineyard. My beloved hath a vineyard in a very fruitful hill."

Clement of Alexandria (150 – 211 AD) suggests that Gen.49 v 11, points to the blood of Christ or His Passion. "Binding his foal unto the vine, and his ass's colt unto the choice vine; he washed his garments in wine, and his clothes in the blood of grapes."[52]

As we can see this represents an enormous store of associations that would have been known to most of the clergy of a place such as the cathedral.

Boss 9. Oak leaves showing galls.

In those days the oak was the mightiest of forest trees. Others might be taller but none was so massive, strong and long lived. The oak was especially sacred to the Celts; pagan they may have been but they knew where honour was due. Christianity need feel no shame in taking that aura of honour and applying it to matters of the deepest significance to them. St Augustine had specifically encouraged the Christianising of heathen practices rather than trying to eliminate them. He knew that one could not change long held beliefs by merely banning them. So the oak comes into our iconography with a penumbra of ill defined but deeply emotive 'meanings'.

Boss 9. Oak leaves and galls.

The Greeks held the oak tree to be sacred. The oracle of Zeus at Dodona in N.W.Greece was regarded as the oldest. There the priests revealed God's will from the whispering of the leaves of a sacred oak.[20] For the Romans the oak was the tree of Jupiter. Mediaeval writers such as Dante seem to have had no hesitation in using Zeus or Jove as another name for God. The oak, because of its solidity, endurance, and the fact that it could be broken but not bent, became a symbol of patience, strength of faith and the virtue of endurance of the Christian against adversity. It was one of the trees credited with being the Tree of Life and from which the wood of the cross was made. So it becomes a symbol of salvation.[52] The latter ideas only appeared formally in art in the Renaissance but will have sprung from unformulated feelings of Romanesque and early Gothic times.

In the Old Testament the oak is often associated with the Lord God. Joshua makes a deposition in Josh. 24 v 26, where he writes in the book of the law and marks the site with an upright stone set under an oak. An angel sitting under an oak gives Gideon the message that he is to deliver Israel. Judges 6 v 11. At the end of the same chapter is the episode of the fleece, where Gideon asks the Lord to show him that He means business in commissioning him to deliver Israel. A fleece is made very wet while the ground around remains dry. The message episode was seen as foretelling the Annunciation (an angel brings the message). The wet fleece foretold the virginal conception and hence the Incarnation. This is in the medieval way of seeing 'Types' in the Old Testament for episodes in the New. In yet other places in the Bible, Men of God sit under oaks, or are buried under oaks, or produce new life from apparently leafless and dead substance. I Kings 13; I Chr.10 v 12; Is.6 v 13.

Are the galls there because they tell a spiritual story or are they just a demonstration of the carver's skill? Certainly they are the latter. There may be a connection with something that Pliny noted when writing about the Druids. He said that they held that the mistletoe <u>or anything else growing on an oak</u> was sacred.[57] I suspect that the idea would be too attenuated twelve hundred years later to act as a trigger for the presence of the galls and caterpillars as on Bosses 29, 34 and 35. Nevertheless oak galls were a source for the tannin in the ink for the scriptorium. What could be more holy than material used in writing the word of God? The other sort of gall, or oak-apple, like a marble and not featured here, would have been the primary source for tannin. Albertus Magnus, (1200-1280 AD), noted both the presence of galls and the maggots that might arise from them. N.Pevsner wonders if this was held to be an example of spontaneous generation [62] but adds that there is no indication this is what Albertus meant. Worms in general at this time were held to arise by spontaneous generation.[4] There are maggots or small caterpillars on the leaves of Boss 34.p.52, and it is possible that this is intended to evoke an analogy to the 'spontaneous' pregnancy of the Virgin Mary.

Acorns tell us that these are indeed oaks. They were also the autumn staple for pigs prior to their winter slaughter. They and many other nuts acquired mystical/spiritual interpretations that are described later. p 39.

Boss 10. The central boss of the whole Lady Chapel. Hawthorn and Maple.
The leaves and the fruit are placed more for decorative effect than they would appear in real life.

Maple leaves and seeds appear very often in church carving. They appear so frequently and in such important positions, not just at Exeter but also at Southwell Cathedral, Wells and York that one feels they must have an as yet undefined significance. All are dedicated to the Virgin Mary or have close connections with her. It is not clear what this significance is and I propose a link to the sycomore of the Flight into Egypt, the plane tree and waters of spiritual refreshment.

Maple leaves are one of the few leaves used commonly in illustrated manuscripts such as Psalters. They and ivy can easily make delightful patterns for borders and in-fills.

The medieval drinking bowl, the Mazer, was made from maple wood. Examples with silver rims and mounts show that they were used to hold the communion wine. Large ones were possibly used as a *grace* cup to drink from after grace in a cathedral refectory.[1]

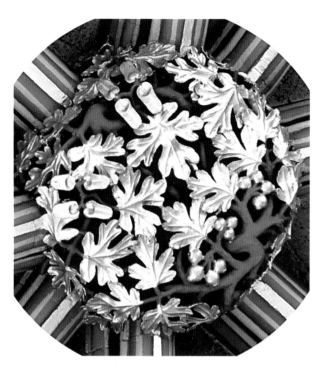

Boss 10. Hawthorn and Maple.

The most significant association may be in the stories about the **Flight into Egypt**. One such describes how an exhausted, hungry and thirsty Holy Family arrives at Matariyeh just to the north of modern Cairo. It is on the outskirts of the then capital Heliopolis. They ask for help but are refused. They come out the other side and sit down under a 'sycomore' tree. Immediately a well of sweet water appears with water that is better than anywhere else in the Nile delta. The family is refreshed. The place remained a place of pilgrimage for both Eastern and Western Christendom certainly into nearly modern times, maybe even now.[18.44] The local 'sycomore' is a variety of fig but westerners would not know that. Sycamores as we know them were allegedly rare in England in the 13th century. They were introduced into plantings for great houses in the 15th or 16th centuries.[49] It has also been said that the Romans were the first to bring them here. There is a very obvious sycamore on St Frideswide's tomb in Oxford Cathedral, carved in 1282, so it may have been more common than botanical history suggests. There will be a difficulty equating maple with even the biblical idea of the sycamore unless the following mental gymnastics are allowed. A sycamore is an 'Acer' and that would have been recognised even then. An 'Acer' is a maple in western European tradition.

So we have the equation:-

Mary sits under a sycamore
Mary sits under an acer
Mary sits under a maple.

These stories were well known. Mary and the sweet water that she and the child receive by grace under the shade of 'maple' make a very possible source for the honour in which this tree was held.

The idea of sweet water brings in a host of associations. For instance: Rev.21 v 6, "I am Alpha and Omega, the beginning and the end. I will give unto him that is athirst, of the fountain of the water of life freely". Rev.22 v 1, "And he showed me a pure river of water of life, clear as crystal, proceeding out of the throne of God and of the Lamb …on either side of the river was the tree of life, etc". Moses strikes the rock when the water fails in the desert; Ex.17 v 1-7. This was seen as a 'Type' of the episode in the crucifixion where Christ's side is pierced and the waters of salvation pour out.

At Southwell Cathedral there is a carving of the Flight into Egypt on the Sedilia. Prominent in the foliage at the foot of the Holy family is a single large maple seed. (Highlighted in blue here)

Jesus speaks to the Woman of Samaria saying: "whosoever drinks of the water that I shall give him shall never thirst: but the water that I shall give him shall be in him a well of water springing up into everlasting life." Jn. 4 v 14.
In Jer.17 v 13 it speaks of "the Lord, the fountain of living waters."
One of Mary's symbols is 'The Well of Living Waters'. She is also the 'Fountain of Life'. Ps.36 v 9.

N. Pevsner makes the point [62] that maple is confused with plane tree in five out of six medieval authors:
St Isidore of Seville 7th C; Hildegard v. Bingen (1098-1179 AD); Thomas of Cantimpré (1230–40 AD); Vincent de Beauvais; Bartholemew the Englishman (1230-40 AD), all are confused, and only Albertus Magnus describes the plane tree correctly.

Southwell Cathedral
Sedilia
Flight into Egypt

The plane tree was one of the trees that 'belonged' to Mary as in Ecclesiasticus 24 v 17-19; "I was exalted like a cedar in Libanus, as a cypress on Mt Sion. I was exalted like a palm tree in Cades and as a rose plant in Jericho. As a fair olive tree in the plains and as a plane tree by the water in the streets."

L.Behling[8] states that the maple is a Mary plant. She points out that maple, sycamore and plane were used interchangeably to carry the same spiritual associations. The sycamore is the Mountain Maple or Berg-ahorn in German. It is also the Faux Platane or False Plane in French. So it is easy to see how cross meanings could develop. There are many references to the shade provided by the plane tree and how it revels in having its roots near running water. The leaves of the plane can signify the good works of the Christian. Indeed a plane appears on the grave of a German Duchess who dedicated her life to the poor. Hugh of St Victor saw the leaves of the plane as 'Good Works'. They clothe the tree just as good works clothe the upright. The Good Works are a gift just as the water is a gift that feeds the tree.[8] Far from being just a pleasing decorative shape; the maple leaf can be seen to be a potent conveyor of spiritually beneficial associations.

Hawthorn will be discussed later. p 40.

Boss 13. Bay leaves.
The next boss to the south of the previous one and the next one to the south again, No 14, may have significant clues to the iconographic programme for the whole Lady Chapel and Presbytery.

Boss 13 is a truly remarkable piece of carving. The undulations on hundreds of small leaves and the whorls that one can distinguish are a true *tour de force* for the carver. The

leaves unfortunately are not absolutely like any tree. They are very nearly **Bay leaves** and Bay features significantly in analogous positions in other cathedrals, notably Reims.

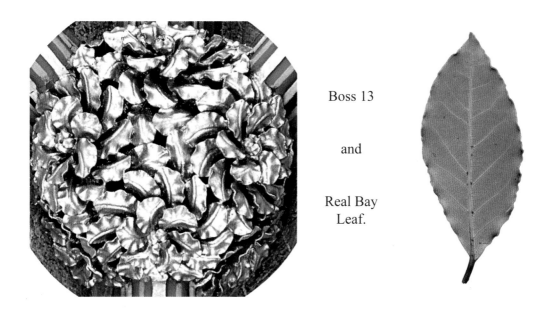

Boss 13

and

Real Bay Leaf.

'Laurus nobilis', the laurel of the ancients that we know as the bay tree, has several classical associations which may or may not have been known to the cathedral chapter. It was sacred to Apollo for Daphne was changed into one when he chased her. So it acquired symbolism of poetry, prophetic gifts and triumph. Victors at the Pythian games were crowned with laurel. In much later Christian symbolism the laurel retained the idea of triumph, and added eternity and chastity. It was a symbol of chastity because it retained its green leaves uncorrupted and also because, in antiquity, it was consecrated to the Vestal virgins. It is a symbol for the Virgin Mary because she epitomised the above features and because her words were as fragrant as the leaves of laurel.[52]

In the Legends of the Madonna for example, as recorded by A.B.Jameson,[45] and in The Golden Legend [70] as well as in the Apocryphal Gospels, there is the story about Mary's own conception. This was very well known and features in numerous pictures in western art. Anna and Joachim were apparently sterile. Joachim had been ejected from the Temple and proper Jewish society for failing to produce a child. He went off into the wilderness. Anna, encouraged by her maid and in a fit of nostalgia, puts on her old wedding dress and wanders into the garden. She looks up into a tree - a bay tree in many accounts - where she notices some sparrows, which only emphasises to her the plight she is in. Suddenly, Gabriel appears and tells her that she will become pregnant. She is of course delighted, and rushes out to meet Joachim at the Golden Gate. He has been told by the same angel to return home. Anna is pregnant and, in time, produces Mary. So is set in train the whole saga of the Immaculate Conception. This particularly good carving would have been a fitting tribute to this new doctrine.

On the interior of the West façade at Reims, where the Announcing Angel speaks to Anna and Joachim, Bay appears in the compartment below the angel.

The point is that a sterile woman becomes pregnant by the action of *grace.*

Boss 14, Corbel C and Boss 1a.

For Corbel C, see p.24. and Corbel 1a, p.13.

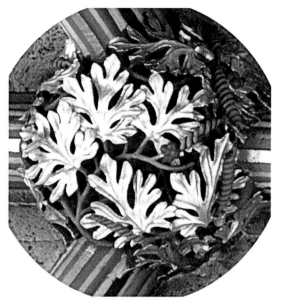

Boss 14. White Bryony.

All three have this five lobed, irregular edged, rather long fingered, variety of leaf and the tendrils are more tightly coiled than in a vine. The berries are in a group of four or five as on bryony and unlike the bunch of fruit on the vine. My Devon botanical advisors and I see this as **White Bryony**; Bryonia dioica. This would be an unusual plant around Exeter for it prefers a chalky soil. It does appear in carving in other places. These include: St Frideswide's tomb in Oxford, the first phase of Norwich Cloisters, the Lady Chapel at Ely, the chapter house of York Minster, the chapter house of Southwell Cathedral and probably others. The embellished form owes more to the idea "Bryony" than to a facsimile. On the face of it this seems to be a very odd choice.

The folklore name for white bryony in the south of England was mandrake.[35] Mandrakes were famous and have the most lurid stories to accompany them. They are native to the Mediterranean region. They were powerful, potent aphrodisiacs and fertility agents and very sought-after. It was exceedingly dangerous to attempt to dig up a mandrake, for the roots, which looked like miniature human beings, would scream, and anyone who heard the scream would die. The trick employed was to tie a dog to the root, move far away, and call the dog, which would pull up the mandrake and die in the process. The illustrated books of the time delighted in picturing the episode and even simple folk would know the tale. So famous was it that at country fairs there were people who had dug up bryony tubers, carved them into human shapes and sold them as mandrakes. They even went so far as to sow grass seed on the head to mimic hair. In church if one heard the word 'mandrake' in an Old Testament reading one would have an immediate picture of white bryony.

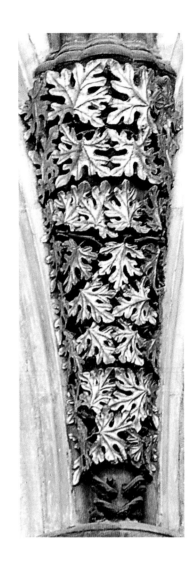

Corbel C

and

White Bryony.

Mandrake occurs only once in the Bible, in Gen. 29 & 30. This is the story of Jacob and how he had to serve seven years for the pretty Rachel, then on his wedding night was palmed off with plain Leah, her elder sister. He was not best pleased with his employer Laban who said that he would have to serve another seven years for Rachel but that he could have her to wife after a week. Leah goes on to produce four sons in quick succession, of whom the last is Judah, but Rachel remains infertile. Rachel gives her maid to Jacob and she produces children, which only serves to highlight Rachel's disappointment. Leah now 'ceases bearing' so gives her maid to Jacob, and she produces two sons. At this stage Reuben, Leah's firstborn, finds some mandrakes in the fields and takes them to his mother. Rachel hears about it and asks for some, thinking no doubt that they might work where everything else had failed. Leah rounds on her and says, "You have taken my husband now you want my son's mandrakes also." Leah attracts Jacob again and bears two more sons and a daughter. <u>Then:</u> "God remembered Rachel, and God hearkened to her, and opened her womb." She goes on to produce Joseph.

The rest 'as they say' is history. He was one of the patriarchs and, as a Type, his adventures were seen as prefiguring episodes in Christ's life. He is thrown into a well, prefiguring the entombment and descent into Hell. He was sold for twenty pieces of silver. His coat of many colours was seamless like Christ's robe. He ends up in Egypt as the chief minister and saves his people from famine, and we begin the story of Moses and the deliverance of the Jewish nation. This surely is another example of a sterile woman achieving her and God's purpose through *grace*. Judah, who was Leah's fourth son, goes on to create the line that will include Jesse, the House of David and Christ's family tree. The mandrake, alias white bryony, is involved in both the physical and the spiritual family trees of Christ.

On the inner side of the West façade of Reims Cathedral, white bryony, with the vine and artemisia, appear below a very authoritative figure in the bottom left hand corner. The whole Christian epic unfolds above him.[8] I see this as Jacob / Israel.

Rachel and Leah were also seen as an Old Testament counterpart to the Mary and Martha contrast in the New.

One can now see how appropriate it is to have bryony as the very first boss at the East End. Almost the whole genealogy of Christ begins here. *See Note 1.p 65.*

Boss 12. Birch(?) & Comfrey.

Just to the north of the mid-line.

I find the serrated leaves difficult to identify with certainty. They have been called aspen and they also look like the **Hazel** leaves of Boss 6, except that they are arranged in a formal pattern. They also look very like **Birch** leaves.

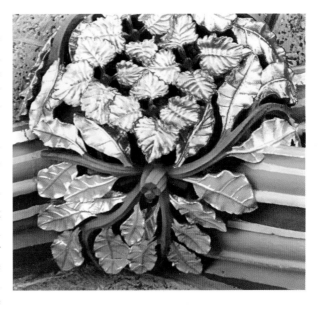

One of the great spiritual mystics of the middle ages was Hildegard v. Bingen, (1098-1179 AD). Her thoughts were given great authority and she was the author of a book about the medicinal properties of plants. Each plant was given the quality warm or cold. Warm plants included all those good for healing and, by extension, were good for the soul. Cold plants were potentially harmful and only affected the physical side of mankind.[8] She rates birch among the warm plants and describes how to make a healing potion. Birch and hazel appear on the same capital of the choir screen of Naumburg Cathedral.

The outer ones could be comfrey or even lungwort. Only **comfrey** has the prominent veins underneath like these. (See p 11.)

There is a potential connection between these plants and Mary. Comfrey had the local name "Abraham, Isaac and Jacob" from the variation in the colour of the flowers.[35] This would connect directly to the story of Jacob, Rachel and Joseph of Boss 14. As a herb it was a famous wound healer much used by housewives and doctors.

If one chooses to see the leaves as lungwort, *Pulmonaria* then the white blotches on the leaves of that plant were held to represent drops of Mary's milk. There was a legend that Mary stopped on her way to Jerusalem at the first Candlemass to give her baby the breast. Some drops of milk fell on the plant at her feet and they remained spotted forever as lungwort, or the Virgin Mary's milkdrops.[18]

Boss 11. "Mugwort" leaves that will be discussed later. p.33.

Boss 15. Mulberry.

'Curious fruit or flowers', is how the web-site describes these. They are very odd. The Devon botanists came up with the suggestion of **mulberry**. Normal mulberry leaves are more regular, but the textbooks confirm that deeply lobed leaves do occur on some species of mulberry. The fruit is a passable attempt at a stylised version of a mulberry. If it *is* a mulberry then what is the connection?

In antiquity the mulberry was a symbol of Wisdom because it was the last plant to bloom, waiting until the chill of winter had left. Christianity took over the same symbolism. A Richard of St Laurent (d. 1230 AD) said that it could represent either Christ or Mary, because the fruits were first green then red then black. He saw the Virgin as green in her sanctity, white in her virginity, red in her passion and black when witnessing her son's passion. St Bernard of Clairvaux said that because the mulberry was used in the crown of thorns it could therefore be a symbol of the passion of Christ.[52] In the fifteenth century, i.e. 150 years after these carvings, the mulberry was given the synonym 'sycamore'; as in "Sicomoris, fructis coeli, vel mori." Sloane. MS.3548: "Sycmore, fruit sublime even unto death."[38]

Ecclesiasticus (Apoc.) Ch.24 is all about Wisdom, who she was, what she did, and with many associations, some of which have already been mentioned. E.g. v 14: "I was exalted like a palm tree in Engaddi, and as a rose plant in Jericho, as a fair olive tree in a pleasant land and grew up as a plane tree by the water." v 9. " He created me from the beginning before the world, and I shall never fail". The Wisdom of Ecclesiasticus was equated to the Virgin Mary by many ancient commentators. So maybe these are mulberries after all.

Mulberry appears on the Naumburg choir screen capitals. Hildegard v. Bingen says that it is a 'warm' plant and leaves in wine are excellent if one has been poisoned.[8].

It figures in the Bible in Luke 16 v 6. and II Samuel 5 v 24. but neither passage appears to give it a spiritual significance and in neither is the translation that certain.[77]

Boss 16. Two goat heads eating ivy.

Goats eating leaves are, amongst other things, a Bestiary inspired shorthand for healing via the Tree of Life.[69] This is the 'meaning' here. There are more goats at Boss 34 p 53, where there is a brief account of their 'meaning'.

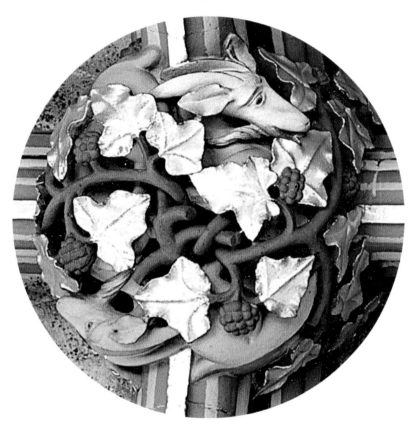

Ivy occurs frequently in carving, there is some more at bosses 14a and 40 p. 51, Corbel C1. p 37.

In antiquity ivy was sacred to Dionysus, the god of wine because, like wine, the older it gets the stronger it becomes. Wine induces sleep and thus came to symbolise death.

Christianity took the metaphor one stage further by seeing in death but a doorway to everlasting life.[21] It is evergreen and so was a symbol for eternity in Romanesque carving.[6] Ivy also came to mean attachment and fidelity because it clings so closely to its support. There was a fourteenth century poem in which it was allied to the Virgin Mary.[52]

Ivy was 'female' as a contrast to holly that was 'male', [33 pp33-34] and was also used for strewing as Palm branches in Palm Sunday processions.

Boss 17.

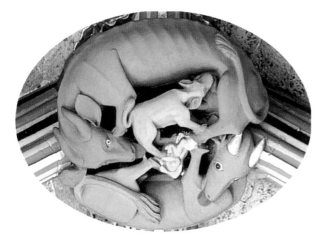

I have no knowledge of a particular story that fits this picture of a **cow suckling her calf,** and the small bull licking himself beside them. The Bestiary has just this picture of a bull licking his flank. It says that they will show their affection for each other by frequent lowing, and it also gives many other 'meanings.[4] This boss makes a very good 'country' metaphor for the Holy Family. Mary nurtures Christ, and Joseph is slightly out of the action.

Bosses 18, 21 & 22. I know too little about heads and head-dresses to comment on these bosses except that the four heads together are possibly a choir. They are encircled by a vine and grapes. Metaphorically they are in the vineyard.(see p17.)

 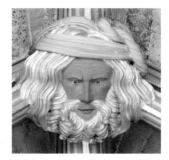

Boss 19. Fish biting other fish and **Boss 23, a fox on his back being approached by some geese;** both give the same message: "Beware the wiles of the Devil."

The Fish represent the story of the Aspidochelone, a Bestiary version of the whale.
Two stories come with it of which only this is frequently carved. The design of a big fish swallowing a little fish makes an easy carving in all sorts of places on bench ends, pulpits and misericords.

The big fish, here with large rough scales on his back, has breath with a very sweet smell. With this he lures little foolish fish into his enormous jaws and swallows them. "The same will befall those who are not firm in their faith, and yield to all delights and temptations as if drunk with scents; and then the devil swallows them up."[4]

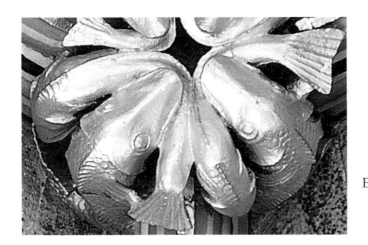

Aspido

Earl Soham

Boss 19

Boss 23

The Fox, having rolled in some red earth, is lying on his back pretending to be dead. We see him from underneath. The green feathery leaves do not appear to be of any significance. They are like artemisia, and may indicate the bitterness of wormwood, a species of artemisia. He has one bird (possibly a goose for geese typified the foolishness of, especially female, lay folk) in his jaws; others are investigating this apparent corpse. But he has woken up; the fate of the one is certain, the others have yet to realise their peril. "The fox is the symbol of the devil, who appears to be dead to all living things until he has them by the throat and punishes them. But for holy men he is truly dead, reduced to nothing by faith."[4]

Boss 23a. A Thistle.

At the West End, as one leaves the Lady Chapel, is another unusual leaf-pattern. The web site calls it oak. It has a curious long stemmed fruit rising from the centre. The botanists suggest a '**ground or stemless thistle**'. These could well be thistle leaves and the short stems of the flower of that variety. Alternatively, **Carline thistles** appear in later iconography and it is just possible that this carving shows one. Carline is a shortened form of Charlemagne. Legend has it that an angel revealed to him the virtues of this thistle against the ravages of the plague.

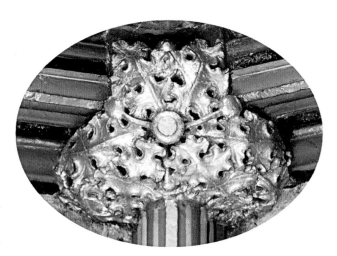

The Milk thistle, though not strictly a native species, was special to Mary for the white flecks 'came' from drops of her milk. This could be a stylised form with 'incorrect' flowers but good leaves.

Thistles because of their thorns, are used later as a reminder of the Passion of Christ. It is most likely to relate to Gen.3 v 17-18: "Thorns also and thistles shall it bring forth to thee, and thou shalt eat the herb of the field."

It is of interest that there is a thistle boss in a very similar position at Naumburg cathedral. It is in the entrance passage to the choir.[8]

Milk Thistle leaf.

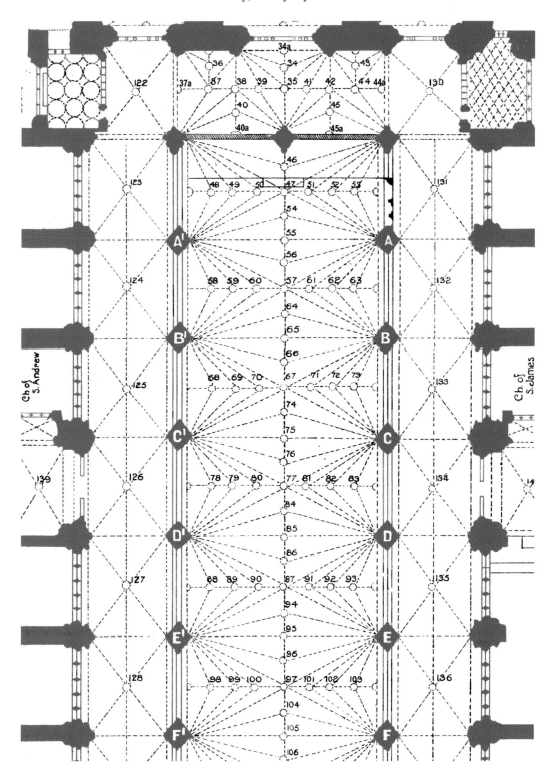

Now leave the shelter of the Lady Chapel and move next to the Presbytery at the East End by the altar. In the Rite of Sarum, a liturgy created in 1078 by St Osmund, Bishop of Salisbury, processions on feast days would start from the altar. They would then move west to the opening into the north aisle, into the ambulatory and round the east and south sides, returning through the other opening to the choir; or, on great feast days, move the length of the church along the south aisle and return up the centre. We shall follow the short route.

Above the altar is the Coronation of the Virgin. **Boss 47**. The ultimate accolade is bestowed on the Virgin. This picture was becoming established as one of the signature pictures of the theory of her Immaculacy.[53]

The corbels on either side of the altar are in prime positions. They are beautifully carved and represent species that have important associations so they are probably of more significance than mere decoration. Corbels A to D on north and south sides are accurate pieces of carving and illustrate clear botanical specimens.

Corbel A 1; Bosses 11, 20, 33, 41, 126. These are 'Mugwort' leaves but it is better to give them their species name "Artemisia", or their medieval name "Mater Herbarum", Mother of Herbs. [for Boss 41 see p 53.]

Boss 126

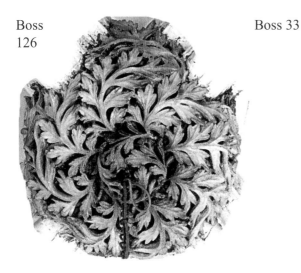

Boss 33

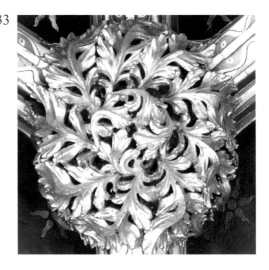

The infelicitous name mugwort comes from the Old English 'midgewort'. It tells us only that branches could be used to ward off midges. It was known across Europe as Mater Herbarum and its magical properties were famed throughout Europe, Asia and China.[35] This must reflect lore with a very long history - probably dating back to Bronze Age times or before. Though it is only the time since the codification of Greek myth that is relevant to Christian symbolism. Besides being The Mother of Herbs, it was the herb of St John's eve, midsummer's day. This was another magical time. Herbs picked and dried in the smoke of the midsummer-eve bonfires were hung over doors to keep away the powers of evil; a practice that was known in 14th century England.[35] The name artemisia gives us the other clue as to its significance.

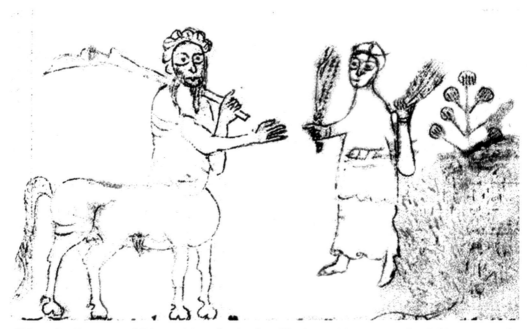

Chiron the Centaur and Diana with *Arthemisia leptafillos* (*Artemisia campestris*, L., Field wormwood); *Lapatium* (*Rumex*, L., Dock); British Library, Harley 5294, fol. 14.
Twelfth century, 255 x 150 mm.

Artemis was a female God and a twin sister to Apollo. In the Roman pantheon Diana was her equivalent. Both were chaste and demanded chastity of their followers. One of Diana's attributes was the moon, as it is for the Virgin Mary. In legend Artemis / Diana endows Chiron, the centaur, with the gift of healing through plants and medicinal herbs and she does this by presenting him with **artemisia.**[16] Chiron passes this knowledge on to Aesculapius who passes it in turn to Plato. Chiron the centaur was seen as one of the archetypes later to be embodied in Christ. Note that this centaur has a wound in his <u>right</u> side to confirm that he is indeed a metaphor for Christ. This accounts for the frequent appearance of 'good' centaurs in church carving. There are such on a boss in the nave, Boss 211, and a misericord that shows a centaur firing an arrow (Holy Spirit) at an impaled dragon. (p 67.)

In the manuscript picture, Diana gives Chiron both artemisia and rumex (Dock). Dock has not passed into the spiritual story but it is well known to soothe nettle stings. One wonders if that story started here. Certainly dock is used even now as an effective cure for the pain of a nettle sting.

Corbel A 1.

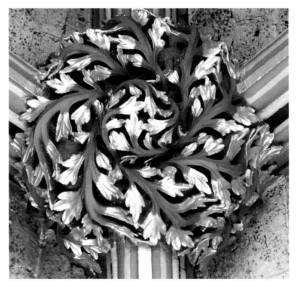

Boss 11.

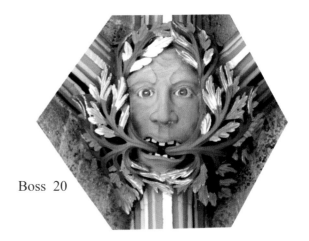

Boss 20

Just as the old gods had given the power of physical healing to mankind, so Mary had brought the power of spiritual healing to mankind via her Son. Mary, the second Eve, to whom all flowers were dedicated, was indeed a 'Mater Herbarum'. Artemisia could almost be shorthand for the whole of the Christian message. Good news, redemption, salvation are just some of the spiritual ideas the faithful would find implied in this succinct metaphor.

When one knows this healing story it is easier to follow the thinking that leads medieval sculptors to place artemisia in other very significant positions. At Freiburg im Breisgau, in the main entrance doorway, a central trumeau presents a Virgin and child. She stands on a corbel under which sleeps Jesse. From a *wound* in Jesse's right side a magnificent coiling spread of artemisia rises behind Mary while above is a lintel of roses. Normally it is a vine that grows from the loins of the sleeping Jesse. It illustrates the famous passage: "And there shall come a rod out of the stem of Jesse etc." Is. 11 v 1-2: "And the spirit of the Lord shall rest upon him, the spirit of wisdom and understanding, the spirit of counsel and might, the spirit of knowledge and the fear of the Lord." A little lateral thinking by the designer introduces one to a deeper spiritual experience.

There is truly a very rich assembly of associations for this seemingly inconspicuous plant. One sees it on every roadside - a tallish pointed plant with dark green divided leaves, silver underneath.

If you were a medieval traveller, the herbals advised you to put a leaf in your shoe. This would guarantee an absence of weariness on your journey.

Corbel A. Boss 44. Hop leaves & possibly Broom pods.

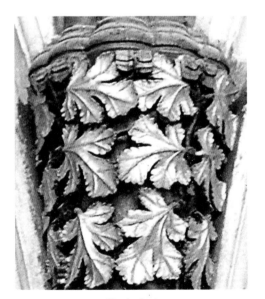

Corbel A

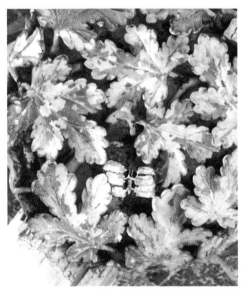

Boss 44

They look like Hop leaves.

There are no coiled tendrils of vines, and they are too big and serrated for maple. The snag with the hop identification is the small seedpods at the top of the corbel and deep in the interstices of boss 44. A hop should have quite a clump of a flower. These are, or look very like, broom pods and may have nothing to do with the leaves. Hop, '*Humulus lupulus*,' was allegedly not used to flavour beer until quite late in the Middle Ages. Prior to that they used a

variety of astringent flavours including ground ivy, marjoram, buckbean, artemisia, yarrow, woodsage, germander and broom.[34]

There were hop gardens at the Abbey of St Denis in 768 AD. They were cultivated in the Viking settlement at York, 900 AD. Pliny mentions the tips of the hops being brought to market in small bundles to eat as a vegetable. Gerarde, [27] in his herbal, is very scathing of their edible qualities so one wonders what the monks really did with them.

At this point we experience classification by association. Mary was the Madonna of Humility, the very personification of Humility, *Humilitas*. Humility conquers Pride, the greatest of the seven deadly sins.

Humulus and *Humilitas* would be puns on each other. Rosemary Woolf [76 p85] points out that in the Middle Ages puns were viewed quite differently to the modern way: "They implied synthesis, for they were thought of as a means of revealing underlying correspondences. Ambiguities of meaning were not random, nor similarities of sound comic coincidences, but both were linguistic indications of the intricate unity of the divine plan. Puns were therefore used for the most august subject matter, particularly when a paradoxical treatment was appropriate, as for the Incarnation."

They liked to make what seem to us to be false associations, as in these Bestiary examples.

"The Beaver, Latin name *Castor* is so called because it castrates itself." [This should be *castro*.]

"Apes are so called because they ape the behaviour of rational human beings."

"Horses get their Latin name *Equi* because when they are harnessed in a team of four they are equally matched, in equal size and with equal stride."

As one can see, this is all nonsense but sounds almost sensible. *Humulus* and *Humilitas* sound similar but have different roots. *Humulus* derives from the Old English *humele*.[35] *Humilitas* is Latin. The makers of puns could ignore any sophistry involved and use such a correspondence quite happily. As a pun they are much less far-fetched than the Bestiary examples above. So it is possible that the 'humble' hop is one of the many 'signs' of the Virgin of Humility.

Those seed pods; one could pretend that they were maple seed cases. But these are so accurately carved elsewhere that to suddenly change their form here is an unlikely scenario. Could they be broom pods? They certainly look like them. There is a Plantaganet king on the throne and the name Plantagenet derives from *Planta Genista,* the wild broom. It is not until Edward II time that broom pods appear as emblems in royal painting - or so I am assured. But broom pods had been used as an emblem for the new royal line since the ascent of Henry III in 1216. This is some eighty years before our corbels. Were the carvers putting in a royal cipher as a mark of respect for the monarchy?

At a more spiritual level, were they using broom pods as a sign for royalty? Broom pods could be the floral equivalent of the royal crown. Mary was the most humble and at the same time the most royal person known to Christendom. This duality of roles could well explain the otherwise apparently incongruous association of broom pods with hops. The Coronation of the Virgin is taking place above our heads at this point and this may be a subtle reminder of her status.

As Thomas Aquinas says, "The most hidden things are the sweetest."

Corbel B.1. Two species of Oak showing galls.

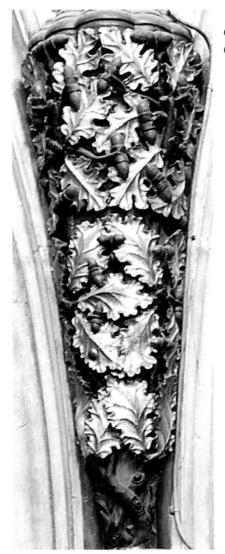

Corbel B 1.
Oak

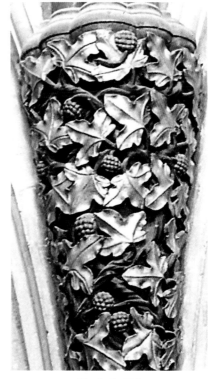

Corbel C 1.
Ivy

Corbel B. Vine and grapes. See p 5.

See Boss 8. p 17 for thoughts on the Vine.
See Boss 9. p 18 for thoughts on Oaks.

Corbel C.1. Ivy plus fruit. See Boss 16. p 27 and Boss 40. p 51 for thoughts on Ivy.

Corbel C. White Bryony. See Boss 14. p 23 for thoughts on White Bryony.

Corbel D.1. Hazel plus nuts, & Boss 6. See also Boss 12. p 25, Boss 39 p 51.

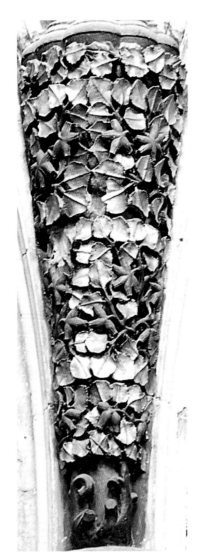

Corbel D 1. Hazel.

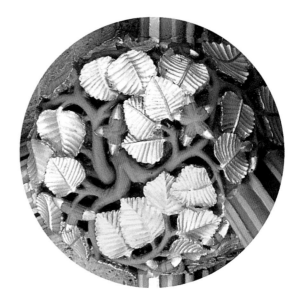

Boss 6. Hazel.

The Hazel was one of the trees that gave shelter to the Holy Family on the Flight into Egypt. It produces its catkins (also known as Palm) very early in the year about the time that the Church commemorates the *Fuga Christi in Aegyptum*[18p200].

The Hazel was a medieval symbol of fertility and a 'tree of knowledge', so a proper material for all rods of power and hence a proper wood for divining.[35] Grigson continues that it was an apotropaic plant (warding off evil) and one brought into the house in May, along with hawthorn and rowan. It was decidedly pagan and needed Christianising, which it duly received in the northern Church.

In some excavations of a few 12th C. burials in France, strands of hazel were found on the body or in the coffin,[8] possibly with evil-averting intent.

Richard Mabey [49] describes an interesting custom at Abbots Ann, Hants. At the funeral of an unmarried person of unblemished reputation - one who had been born, confirmed and died in the parish - a Virgin's Crown of hazel-wood is made to which are attached five white gauntlets. These are to challenge anyone to deny the claim. Provided there is no challenge, it will end hung in the roof of the church forever. I find this a most significant pointer to a probable medieval association of the hazel with virginity and so with the Virgin Mary.

In sermons of the 13th and 14th centuries, 'Mary is equated to the hazel tree that breaks out in nuts in all perfection and sweetness.'[8]

Nuts.

Nuts carry a generic meaning in carving. The nuts can be hazel, oak / acorn, walnut, and almonds. The St Victor school of theology, made famous by Hugh (1096 – 1141 AD), and Adam, encouraged a mystical way of interpreting the world.

The nut was given significance in the following metaphor: The whole nut is Christ. The outer represents the Passion of Christ because it is so bitter, and from that, the flesh of Christ. The shell is the Strength of Spirit that saved the world as a shell protects the core of the nut. The kernel signifies His deity and the sweetness of His Divinity.[52] St Augustine uses a slightly different metaphor where the shell is the wood of the cross.

Boss 39. Squirrels feed on hazel nuts. See p 51.

A poem by Adam of St Victor, "Splendor Patris et Figura" [32 p67] gives the feeling.

> Frondem, florem, nuccem sicca,
> Virga profert, et pudica
> Virgo Dei Filium.
> Fest coelestem velus rorem
> Creatura creatorem
> Creaturae pretium.

A suggested translation runs:-
'The dry rod brings forth branch, flowers and fruit, and the chaste Virgin brings forth the Son of God. The fleece bears the heavenly dew, the creature the creator, the ransom of the treasure.' Note the pun Virga (rod) and Virgo (virgin).

The rod is Aaron's rod as in Numb.17 v 8, that not only blossomed but also produced almonds; so the nuts become a symbol of the Incarnation. It is an Old Testament 'Type' of Joseph's rod that blossomed to show that he was chosen as Mary's husband.[70]

I wonder if the spiritually minded of that time even "saw" an acorn or a hazelnut. I suspect they went straight into contemplative mode, thinking of the joys and sorrows associated with Jesus or Mary and the similar subdivisions of the Rosary.

Corbel D. and bosses 10, 38 (see p 51), 44a, 125. Hawthorn.

Hawthorn is almost as abundant in our churches as it is in the countryside. Maybe that is going a bit far, but where naturalistic carving occurs it appears very frequently. The name 'May' by which we all know it, suggests an immediate correlation with Mary. "As a Mother, the Virgin Mary is associated with joy, with songs, with dancing and flowers. May, morning of

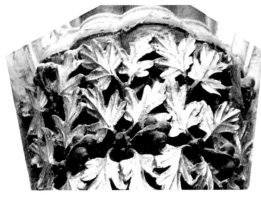

Corbel D

Boss 125

the year, is dedicated to her."[72]

Most significantly May means a maid i.e. a *Virgin* in the English of the time.

A XVth C. Carol contains this verse. It is a carol for St Stephen's day.

> I schal yow tell this ilk nyght
> Of Seynt Steven, Godes Knyght:
> He told the Jews that it was ryght
> That Christ was born of a may.[33] (carol 20 . British Museum MS Egerton 3307)

May, or hawthorn, carried with it a perennial meaning of virginity in that subconscious of associations that carver and observer shared together. It is therefore easy to understand their enthusiasm for this particular plant and leaf form.

May is named after Maia, a Greek nymph who was the mother of Hermes by Zeus, and was transformed with her sisters into the Pleiades. They are harbingers of summer, and appear in the sky in May. The Romans had a festival in late April-early May in honour of Flora, whose cult was particularly associated with the heady flower of the hawthorn tree. All over Europe the Queen of the May was crowned on May Day and was sometimes married to the Green Man in an ancient fertility rite. The Jesuits tried to sanctify the secular custom and transform the Queen of the May into the Virgin Mary. In this they were largely successful. That 'Green Man' however is **not** the same Green Man that we see in our churches. It is unfortunate that we have the one name for two rather different orders of being. One should also remember that May Day was on what is now our May 13th. So 'May' would have been in full flower and not just starting as it does now on May 1st.

None of these scholarly associations would have meant anything to the man, or the cleric, 'in the street'. May, both the month and the tree, belonged to Mary and that was enough. Hawthorn was a magical plant, powerful against a wide range of evils including lightning. May was brought into the house on May Day to keep evil spirits at bay. Our belief that it is unlucky to bring it into the house dates in part from the Reformation. To be seen to bring it in was to risk being labelled a Papist and follower of the old religion.[49]

It had the name 'Herba Trinitatis', because there are three colours in each flower.[34] Hawthorn produces a bright red berry, often shown as a food for birds. Where grapes can stand for the blood of Christ and the communion wine, it is possible to see a similar analogy for these red berries being the blood. The hawthorn is also one of the trees of which they said the Crown of Thorns was made. The fervent medieval imagination could easily see the berries as drops of Christ's blood, though I know no written record to this effect. (There is documentary evidence that holly berries were seen in this way.)

Birds feeding in church carving almost always mean Christian souls coming to feed on the Blood / Communion wine, or the fruit of the Promised Land. Birds feed on hawthorn berries in several of the bosses.

There is much more folk lore about the hawthorn,(see G.Grigson [35]) but some of the above must surely have played a part in the desire to see it carved on so many roof bosses and capitals.

There are dozens of bosses above us but I wish to comment on only seven. See p 5.

Boss 58. Marcolf.

Riddles held a particular fascination for the people of the Middle Ages. Crosswords must satisfy a similar need nowadays.

This picture relates to a riddle set by a King to one of his subjects in which he says; "Come to me neither naked nor clothed, neither in the road nor out of the road and bring a present that is no present." There were many versions across Europe usually involving a daughter who arrives covered in a net, riding a goat, one foot touching the ground and with a hare under her arm that will run away as soon as it is released.[50] The misericords showing this episode are probably a parable of the Incarnation.[69] However this is a man and pictures a universal prankster of his times, Marcolf. He appears in the margin of many a manuscript.[9] At another level a Jester is essentially marginal in any society, never quite belonging anywhere. As 'The Fool' he was the only person allowed to tell the unpalatable truth. Feudal law, as I

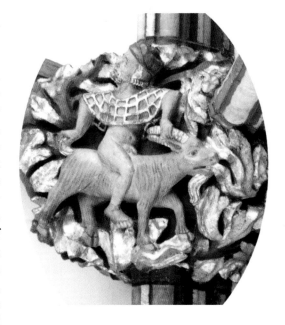

understand it, allowed a Lord or other superior to reclaim estate that an inferior held from him, if that inferior died intestate or in other ways infringed the feudal code. The Church was receiving legacies from people that included real estate, and of course the Church never died. So the feudal Lord lost his land forever. Edward I had acute financial problems and steadily increased the tax on his subjects. There was no 'Income Tax' as we know it because there was no income to tax. Rather, tax was levied on real estate, and this went up to astronomical proportions late in his reign; 40% or more. A Statute was introduced in 1279 - 'De Viris Religiosus' - popularly called the statute of 'Mortmain', that effectively repealed the right of the Church to be exempt from this feudal arrangement. So a donation received from a wealthy parishioner might very well disappear when that person died. The present under the net had gone as Marcolf so poignantly demonstrates,[12] and it would make sense for this to be the reason for his presence here.

Boss 83. Fig leaves.
These are very like fig leaves but have been given a bit of a swirl by the artist. There is one small fig bud just visible.

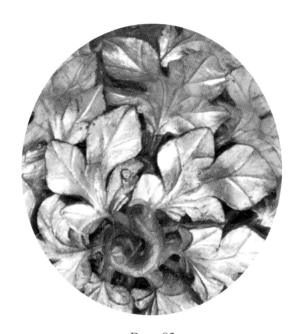

Real Fig leaf. Boss 83.

It is doubtful if figs were grown in England at that time. A basket of figs from Spain is reported at the court of Edward I and Eleanor of Castille in 1290. (F.A.Roach. Cultivated Fruits in Britain. 1985)

If the trees were non-existent a little artistic licence is permissible for someone copying from another's drawing.

The first mention of fig leaves is in Genesis 3 v 7, where Adam and Eve sewed fig leaves together because they knew that they were naked. i.e. it is associated with the Fall and the Tree of Knowledge of Good and Evil.

It is a fruit of the Promised Land in Deut. 8 v 7-8. "For the Lord God brings thee into a good land, a land of brooks and water …………a land of wheat and barley, and fig trees and pomegranates…" It is also a fruit of the Promised Land in Numb. 13 v .23, where the spies sent by Moses into Canaan return with an enormous bunch of grapes, figs and pomegranates. It is in this sense that figs as fruit appear in church carving.

The fig tree is very much associated with Mary and Christ in Song of Songs 2 v 13: "For the winter is past……..the fig tree puts forth her green figs…." Just as it does in this carving.

Other associations occur by the time of the Renaissance.[52] These include: the Tree of the Cross, the Resurrection, the Virgin Mary, the Church, the Synagogue, the Jews and Pharisees, the Damning of the Wicked, Fertility and hence Lust, the Clerics, Charity and Human Nature.

There are similar leaves on Boss 53a near the High Altar and on the capital behind it. They are also on the tiny corbel below the East window.[39] These are all significant points.

My preferred allusion is to the verse in Song of Songs: "The fig tree puts forth her green figs." It all fits the theme of Mary's garden and new life that the Christian could experience in this splendid new place.

Boss 83a. Fruit associated with 'Palmette' leaves.

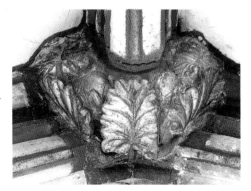

This is not an earthly fruit but one that grows on the Tree of Life. The leaf form is that found frequently in Romanesque carving, along with Acanthus and the 'Tongue' shape, and decorates the capitals of great Romanesque churches in France. This fruit was forbidden to man in the Garden of Eden but is now available in the new heaven to which he will attain. "To him that overcometh I will give to eat of the Tree of Life." Rev.2 v 7.

It is appropriately placed next to the fig leaves boss.

Boss 69. Mermaid or better, a Siren.

The Sirens of Greek myth sang so sweetly that all who heard them were lulled to sleep. The Sirens then revealed their true purpose, which was to devour the now helpless sailors. Odysseus tied himself to the mast and stopped the ears of his crew with wax when he sailed

past their island, so dangerous were they. Sirens were originally bird-sirens who, because of the marine connection, partially evolved into fish-sirens and later to nubile mermaids.

These, in a Church context, illustrate the fatal attractions of the female sex and more generally the whole range of worldly temptations. Examples of each variety occur in wood and stone carving and there is at least one merman at Queens Camel and a beast-headed mermaid at Lacock Abbey.

Boss 79 and 82. A stone-thrower and a pair of wrestlers.

Boss 82. A pair of Wrestlers.

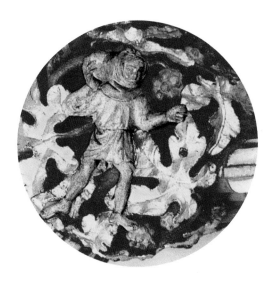

Boss 79. A Stone Thrower.

These are paired in position and may be a male version of the Siren episode above, demonstrating the fatal attractions of the male sex, though there are many other possible explanations for their presence. These include, for wrestlers: (a) The Violent, carried away by

their instincts; (b) Anger, as one of the seven deadly sins; (c) a judicial duel – a function of the Judgement of evil; all three, in Romanesque carving see [6 p301]; (d) The Gemini (Twins). In the signs of the Zodiac they are often portrayed in just this pose, if not actively fighting. They had different fathers and spent half their time in heaven and half in the underworld. They can represent heaven and hell.

The Luttrell Psalter contains scenes of peasant games that include archery contests, wrestling and games of strength. A graceful Stone thrower appears in the side margin of fol. 40v of the Luttrell Psalter but here the sport is more than a single sign for sin. The following suggestion comes from a book by M. Camille[10]. "It becomes an 'exemplum' locating the sin in a social community. The dubious nature of the sport is indicated by the figures. That stone casting was a site of *visual desire* is attested in a beautiful Middle English couplet that describes the sexual prowess of a champion under the gaze of a girl and her disappointment at the puerility of his performance. These men are also 'ready' as the psalm text above them in the Psalter states, not in their hearts to receive God but in their bodies to commit sin". One of the wrestlers is as well endowed as a bull and I think, but cannot be certain, that the stone thrower is making a sexual gesture with his left fist. (Fig sign; thumb between the fingers. See [58].) Certainly his fingers cover his thumb though this is not easily seen in this illustration.

A moralised version of the same picture came in medieval sermons and provides a 'sanitised' glass through which to experience these figures.

"Atte wrastlinge me lemman (lover) I ches
And attte ston-kasting I him forles. (lose)

'Wrestling' is a manner of fighting, and truly no one comes to his love or to his bliss unless he is a good champion and manfully fights against three foes, which are the Devil of hell, his own sinful flesh, and the world. By 'stone', is understood the hard heart of man and woman.[32]" The central boss, 174, of the whole cathedral carries much the same message.(p 66. [in 39 see ref. Index 445. See Förster, Anglia, Anflia xlii, 152, Carlton Brown, 'Texts and the Man', Modern Humanities Research Association, ii. 106-7])

Boss 84. Dogs and hares chase each other.

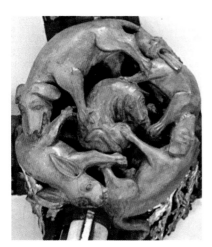

Two fierce dogs chase two fierce hares around a central peaceful dog in the centre.

There is a clue as to the possible meaning of this boss in The Book of Memory.[13.p 244] The author mentions that in a medieval book, (HM 19915) there are many *tituli* in the margins, each enclosed in an elaborately drawn image.

Marginal illustrations are often a way of highlighting the accompanying text and making it more memorable. One *titulus* is of a dog and hare chasing each other's tails and so forming a ring in which is written "*signa humanam benevolentam*" "Mark Human benevolence."

This carving could be trying to say something very similar. The central quiet, faithful, godly, dog contrasts dramatically with the fierce, warring, worldly dogs and hares round the outside.

Leave the choir by the north doorway for the north ambulatory aisle.

Look left at **Boss 129. It shows a sow suckling her piglets.**

This is the story of St Brannock, and tells us that we are in a Divinely chosen place.

The story goes that he was trying to build a church, but the Devil undid his daytime work every night. One night he had a dream in which he was told to build by an oak where he found a sow suckling her piglets. He did, and in no time his church was finished. Another copy of this story appears in the nave, Boss 216.

Boss 126. Artemisia. Corbel A1 p 34 has the story.

Boss 125. Birds eating haws amongst hawthorn foliage. Corbel D p 40 has the story.

Boss 124. Two dragons are so intertwined with Ranunculus (Buttercup) leaves, that it is

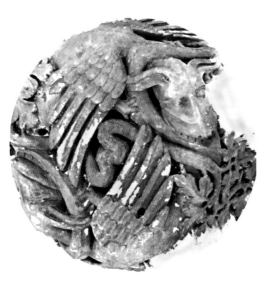

difficult to say if they are biting each other's tails, or feeding on the stems of the leaves. Buttercup appears again round the edge of Boss 42 p 54, and in St Gabriel's chapel, Boss 29a p 60. It features as a major item at Southwell.

Let us suppose that these are regenerate dragons feeding on these leaves. Buttercup is an 18th century name. Prior to that they were known as crowfoot. They also had a myriad of popular names; enough to make a Welsh man's pedigree "back to William the Conqueror" as Culpeper amusingly puts it.[17] Buttercups carpet the fields in May, and some of their names include Maybuds and Marybuds.[35] In Germany they had the names Virgin's leaves, Our Lady's resting place and Pentecost flower. In Spain they were 'Our Virgin's Crown'. There was a legend that the stars of heaven, wishing to glorify the Divine Christ Child came down to earth and planted themselves round the Virgin and Child as radiant buttercups.[48] So there are plenty of associations between buttercups and both the Virgin and Christ.

Boss 123. Oak with Acorns. See Boss 9 p 18 for the associations.

Boss 122. Four winged dragons biting each other's ears.

I see these as an unregenerate lot. Maybe they illustrate the way mankind always seems to be in conflict.

The next boss shows the means to avoid this situation.

Boss 37a. Rue. 'Ruta Graveolens.'

Boss 37a & Real Rue

This is the *Herb of Grace* signifying to those who walk beneath, that they receive grace in much the same way that the congregation would receive grace on their processional route.

Before High Mass, Holy Water was sprinkled on the congregation with brushes made from Rue, the Herb of Grace and the Herb of Repentance.

A later, secular, derivation of this used rue as a destroyer of vermin i.e. it was powerful against evil. High Court judges are handed a bouquet containing rue, or just flowers these days, to protect them against gaol fever.[31] Gerarde, in his herbal, notes that Dioscorides (d.90AD), remarked on its efficacy against poisons of all sorts.[27] It was considered a powerful

defence against witches and used in many spells. It was also thought to bestow second sight.[34] Even Bestiary lore takes something from Dioscorides, and says that the weasel arms himself with rue to ward of the lethal glance of the Basilisk. One is featured doing just this on a misericord at Worcester p 67. So it protects, it gives sight and is a reminder of the *means of grace*.

Boss 36 and Boss 31. Greater Celandine. 'Chelidonium majus.'

Boss 36
Real Greater Celandine.

Boss 31

It appears here and on other great cathedrals in England and France. The word 'Chelidon' is Greek not Latin and means a swallow. The Greek 'Latin' name comes because the story of this plant goes back to the Greeks, and from them, via Pliny and others, to the Bestiary. The greater celandine has bright yellow or golden sap. The swallow, according to Greek legend, uses this sap to treat the eyes of its fledglings. The swallow also builds its nest on the walls of strong buildings, and none better than a church. "Its nests are more precious than gold because they are wisely built. How much better is it to get wisdom than gold. Prov.16 v 16."[4] Even the novice would know Ps.84 v 3. "Yea the sparrow hath found a house and the *swallow* a nest for herself, where she may lay her young, even thine altars, O Lord of Hosts, my King and my God."

It appears on St Frideswide's tomb (1282 AD) in Oxford Cathedral, and she was a benefactress to the blind.

The spiritually minded might have meditated along the lines: sight as a sense of the body, second sight or insight as a sense of the soul; though the universal message is that we are in a safe and hallowed place.

Boss 37. "Caterpillars" on leaves with fruit and flowers.

The "caterpillars" look like those of a hawk moth and are symmetrically arranged in a very decorative form. One needs an enlargement to see that the "caterpillars" have long tails, so maybe they should be classified as some sort of serpent or dragon.

Boss 37

"Caterpillars" on strawberries
and real wild strawberries.

 Snakes and serpents have a number of meanings, and one of them is that of eternal life. [69] They were famed in the Bestiary for their ability to pass through a crack in a rock thereby sloughing off old skin and emerging totally renewed. They literally never died. We tend to assume that all such creatures are evil but that is not necessarily so.

 All - or nearly all - the other dragon-like creatures in this cathedral are feeding on greenery. They are not attacking it but using it as a divine provision. It needs a major shift in our preconceptions to make this transition, but if one does then all sorts of carvings that previously were inexplicable, suddenly make a lot of sense. The heavenly food idea marries well with the eternal life idea.

 The web-site sees these leaves as blackberry or raspberry. The fruit certainly looks very like blackberries at a distance but enlarged they have the calyx characteristic of strawberries. It curls round the fruit and is not turned back and tatty, as it should be with the

other two. The leaves look much more like strawberry. There are no thorns. Maybe thorns were too difficult to carve but I feel sure that, had they wanted to indicate thorns, they would have included a diagrammatic thorn or two. None of the roses have thorns either. Blackberries in Renaissance art were sometimes used to indicate the Burning Bush, and that also was a symbol for the Virgin Mary, for it was touched by fire yet not consumed. Just as God touched her yet she survived. Strawberries are in flower and fruit at the same time just as are these plants. They too are a symbol for the Virgin for she was 'in flower' and virginal, at the same time as she was ' in fruit' and pregnant. Caterpillars - if these are they - stood for the earthly phase of our life. The chrysalis was a sort of limbo and the butterfly was our soul released into a new heaven. However we wish to organise our thoughts for this boss, we come back to earthly beings feeding on a divinely provided food. (See Note 3, p 66.)

Boss 40a. Pea pods and pea flowers.
It is so dark that they are difficult to see but one can make out peas in the pods fairly easily.

Peas also produce flowers and fruit at the same time, and are again a symbol for the Virgin. The flowers appear frequently in illustrated Psalters of a slightly later date. They are rare in carving. The only other example I know is in the Ste Chapelle in Paris p 66.

There is a delightful legend about Mary and her journey to Jerusalem for the ceremony of Purification after the birth of a baby.[18 p176] Mary spoke kindly to a man to ask what he was sowing. The boorish peasant, who was sowing peas, replied that he was sowing stones. "Then you shall reap stones" was her quiet reply. He was very dismayed when, at harvest time, he found nothing but little stones. Ever since, that spot has been called the 'Field of Peas,' and is a place of tiny pea- like pebbles.

It is also possible that there is a pun here. I do not know exactly how they pronounced "peas", but certainly peas = peace was used in carols of a slightly later time.[33 (Carol 14)]

The story of Jack and the beanstalk - or Jack the giant killer - appears on a misericord in New College, Oxford, p 67. The beans are shown as peas. It is obviously a 'good against evil' story. The giant eats lambs for his dinner. The lambs are ourselves. Jack would be a good metaphor for Christ, with his mother for Mary. Jack climbs a pea stalk (Peace stalk in the pun if indeed there is one. I doubt if the pun would work in French.)

Boss 38. Four dragons entwined in hawthorn leaves and berries. See Corbel D p 40.

Two of the dragons bite their wings, or preen. As mentioned in the Introduction, "to preen" is to make straight, rejuvenate and make healthy. They are on a bed of hawthorn. Two metaphors combine to show new life enjoyed in the all embracing care of the Virgin.

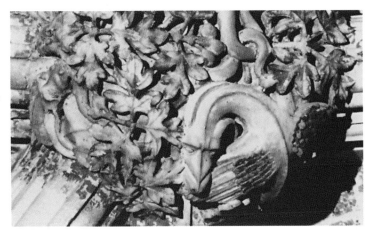

Boss 40. Nine golden birds eating fruit of ivy.

This boss is even more about design than the others. But the principle, that of birds feeding on God-given fruits, still applies. The birds represent us as Christian souls. Ivy also appears on boss 14a and 16 (see p 27 for the depth and breadth of the associations.)

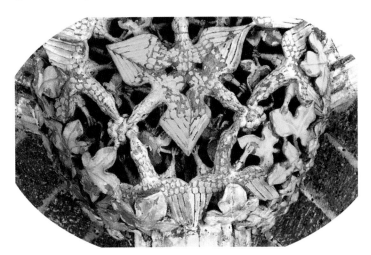

Boss 39. Squirrels eating hazelnuts. See Corbel D 1. p 39 for the picture.

Nuts as a food represent Christ, the Deity and the Holy Spirit. Animals eating nuts can mean the Christian partaking of the fruits of a new spiritual life(p 39). In Bestiary lore, to which squirrels were admitted rather late, the story is told of how squirrels will cross water by sitting on a piece of wood using their tails as sails. We know it in Beatrix Potter's Tale of Squirrel Nutkin. The Bestiary describes how the wood is the Cross, to which the faithful should cling in the stormy seas of life.

When hunted, the squirrel heads for the tree tops, much as the Christian should do, "for there is little security in the things of earth but much safety in the loftier places of heavenly meditation."

51

Boss 35. Pigs eating oak leaves and acorns.

This is a common picture for November or December in the cycle of the seasons. There do not appear to be any other seasonal carvings here, so this one probably relates to the generic idea of ordinary earthy folk, coming to feed on heavenly food.

Boss 34. Goats feed on oak and beech leaves with beech mast in the centre.

There seem to be no spiritual associations for beech. The fruit or 'mast' was a main food for pigs, and it may be here as divinely provided food, with the additional thoughts about the significance of the nuts. (p 39)

There are some very thin small caterpillars or 'maggots' here, presumably also feeding on the leaves. There is just the possibility that they relate to the idea of spontaneous generation,[62] by which many worm like creatures were thought to arrive.[4] This would also provide a link to the idea of the Virgin Birth. Spontaneous generation and asexual reproduction were held up as prime examples of the wonderful ways of the Lord to doubters about Mary's virginity.[4.69] (see Boss 9. p 19)

Caterpillars have been mentioned before as a metaphor for the earthly phase of the spiritual life, they have yet to turn into free-flying butterflies.

Goats have a complicated meaning. The Bestiary made matters difficult because it recognised two species of goat. One is the lustful, hairy 'he-goat' type; the other is much more peaceful and it can stand for both Christ and for Christians. It frequented high places and could tell if the approaching stranger was friend or foe; i.e. it had the capacity for foresight and omniscience. This made it a suitable symbol for Christ. The Bestiary also points out that Our Lord refreshes himself in the Church - and the ' good works of Christians are his food.'

Psalm 104 v 18, states that the high hills are a refuge for wild goats, and the rocks for conies. In this we are the goats and the conies. The rocks are the rock of Christ. Many a bench end and misericord has the picture of a rabbit bottom peeking out of a hole with the head coming out of another. They are conies finding refuge.

The picture of Goats feeding on foliage is an ancient middle-eastern device, taken into Christian art to illustrate the theme of animals feeding on the *healing* plant "Dittany". Several plants have been credited with being dittany; the exact species does not matter. The idea is that we come to feed on vegetation that can be the Tree of Life and/or the wood of the Cross. We are thereby healed. The Bestiary adds: "If preachers are wounded by sin, they run to Christ and are quickly healed."[4]

Boss 41. Two heads with finely cut foliage coming from their mouths. Artemisia.

The Green Man is not pagan in a church context. He is frequently belittled in this manner with the result that we cease to explore for a further significance. We shall understand 'Green Men' much better if we see them as a design for 'Deity' in the broadest sense, rather than as pagan symbols put in to keep the credulous country folk happy. The metaphor associating new spring growth with New Life (See Is.55 v 10-11) is a powerful picture that has been incorporated into much Romanesque and Gothic carving. Sometimes the New Life comes from God, sometimes the soul is 'up there', literally and metaphorically in Paradise, experiencing this New Life as the Green Man.

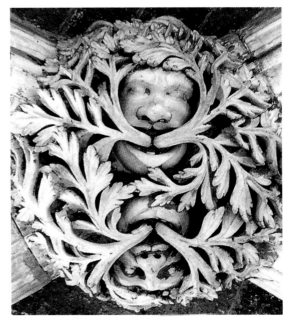

There are inevitable difficulties in any attempt to draw God. A Victorian version that comes to mind is that of an old man with a long white beard and dressed in a nightie. A fierce Norse head, designed to frighten the living daylights out of one, is another. The Church liked to emphasise Christ as Judge and the necessity of preparing for the dreadful day of Judgement while there was still time. An element of fierceness in the Godhead, which would also contrast with the kindness of the Mother of God, may have influenced the direction of some of the designs.

"In the beginning was the Word and the Word was with God and the Word was God." (Jn.1 v 1). What language is God going to speak? In the beginning God created heaven and earth. (Gen.1 v 1). God brings Life. What better way of showing Life than as fresh new greenery? It is a metaphor all can understand. That it also happens to chime with other ancient and "pagan" ideas is a bonus. Christianity delighted in changing pagan observances and giving them a Christian meaning. The Norse head with rather diagrammatic foliage coming from the mouth, appears on Norman or Romanesque carving, and would be better known to us at that time than the foliate head from Rome. The two strands of thought merge in our Gothic iconography.

Artemisia, see Boss A1.p 54, is the original herb of healing sent to mankind. It stands for all God-given means of grace as well as the physical healing that God has provided in His care for mankind. Why two heads here? I do not know but one can postulate that they represent the Father and the Son or that they happen to make a better design as the carver saw it. At Pershore, H&W, there are also two very similar heads sprouting artemisia.

Boss 42. "A formal arrangement of elliptical leaves with trailing foliage round the sides" Herb Paris and Buttercup / Ranunculus.

The elliptical leaves are arranged in a tripartite fashion in the centre, that I see as a clear reference to the Trinity and Deity. See Boss 45a. p 55. These same leaves then make a quadripartite pattern that has a distinct similarity to the arrangement of Herb Paris leaves. There are no other plants that look remotely like this, see p 11. Herb Paris does not grow locally, for it needs shady woods on limestone. The carvers could not have had a sample to copy, instead they would have had to rely on description or a sketch done on a scrap of parchment or wax. Later herbals describe it as being powerful against witches, for such a regular arrangement in nature must mean that it was 'signed'.

Almost contemporary with our carvings, was the Luttrell Psalter. There is a picture of a great feast for Sir Geoffrey beside Psalm 115. In the border of the same Folio, 208r, is a spray of quadripartite flowers that M.Camille says represents Herb Paris.[10] The four petals symbolise the four kinds of love that a man should hold: for one's God, for one's self, for one's friend and for one's foe. I feel that this, or something like this, was one of the messages of the carving.

There are associations with Mary for the buttercup leaves; see Boss 124. p 46 & 60.

Boss 45. A Fox or a Cat is threatening to bite a bird that is feeding on maple seed.

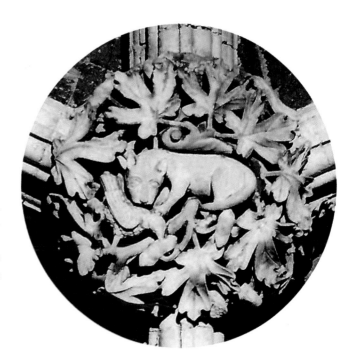

The fox is an archetypal figure for the evil one, especially in medieval carving. The cat is not much better, having an association with hypocrisy and witches. The bird is the Christian soul. Birds do not, to my observation, feed on maple seeds on the tree so this is probably generic God-given food, more particularly, spiritual food from the Virgin Mary; see Boss 10. p 19.

Is the message that, while one is coming to Mary one is safe from the Evil one?

Boss 45a. Pears.

It is very difficult to see anything in this boss. The 'pears' are grouped in threes so they may signify the Trinity. Three, besides being a sign for the Trinity, carries a host of other associations from antiquity. It meant the best in the series good, better, best. Only the best is suitable for God.

In the strongly-geometric Pythagorean mathematics, One was a point. Two represents a straight line. Three was the first "real or proper" number because it represented an area, the triangle. As such it belongs to the deity as opposed to more ordinary numbers.[41] Each pear has a cup at the base, very like the cup on a medlar, but medlars do not come in threes. The wild pear has a small cup like this but is much rounder than this rather small cultivated (?) pear. There are a number of possible allusions. There was a species of pear in Germany, the centre for honouring the Three Kings, called Dreykonigsbaum or Three Kings Tree.[18] But whether the name goes back

to this date I do not know. The pear had the general meaning in antiquity of affection and well being, and was used as a symbol for the Virgin Mary because of its sweet taste. Psalm 34 v 8 "O taste and see that the Lord is good." and Song of Songs 2 v 3. " I sat down under his shadow with great delight and his fruit was sweet to my taste."[52] These ideas are quoted in references from the Italian Renaissance and may reflect a collection of ideas from our late thirteenth century time. The forbidden fruit of the Tree of Knowledge is often pictured as an apple - *malus* for it sounds so like *mala* - evil and is assigned to Eve. In contrast to this the pear is a sweet fruit that is assigned to Mary.[8] Pears were also of value in the morning sickness of pregnancy (See Chaucer, The Merchants Tale.) "Blessed art thou amongst women and blessed is the fruit of thy womb." (Luke 1 v 42.) Is there also this thought here?

Boss 43. Vine with grapes. See Boss 8. p 18.

"I am the vine, you are the branches." We have seen how the vine stands for Christ in the most direct of allusions to vegetation in the New Testament. The grapes add the significance of wine, the Communion wine, and so the redeeming blood of Christ.

Boss 44. Hop leaves and broom pods. <u>See Corbel A. p 35. for the picture.</u>
The web-site calls this maple (?) with fruit, and sees them as similar to Corbel A in the Presbytery. These leaves are exactly like the hop leaves of Corbel A. The fruit is not maple fruit but broom pods again, though this time in sets of six not four. As I have explained at Corbel A, it is very tempting to see this as Mary at both her humblest and most regal, and the boss makes a fitting climax to this part of the processional route.

Boss 130. A bird of prey is disembowelling a pig.
We are now in the south presbytery aisle. A pig in this sort of context may refer to the Jews and this carving could have had strong anti-Semitic overtones. The Jews were not only unpopular because of their perceived ability to accumulate wealth, but were also held up as the people who had killed Our Lord. They had been taxed out of everything they possessed and with nothing left, Edward I had recently ordered their expulsion from the kingdom. The bird of prey could be a reference to the recent actions of the King.

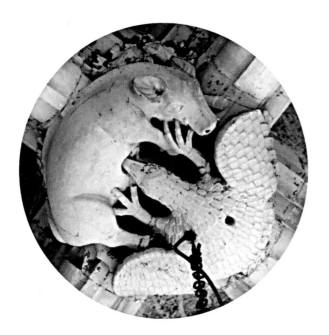

This general picture is more normally associated in the Bestiary with a pair of vultures disembowelling an animal; in the Bodleian version it is a pig. If, instead of a hawk this is a Vulture, then there are direct associations with the Virgin Mary and possibly nothing anti-Semitic at all. Vultures were thought able to conceive without carnal knowledge of the male sex. They were held up as examples of God's ability to arrange matters in this way, for those who were doubters of the real virginity of Mary. They were, therefore, one of the many symbols for the Virgin Mary.

Boss 131. A Rose.

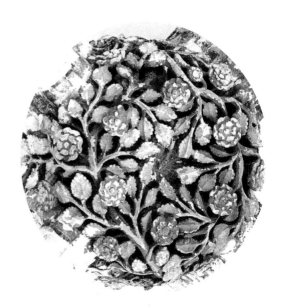

This is a rose without a thorn, and one of the great attributes of the Virgin Mary. Some of the ideas that this boss advances are dealt with at Boss 2. p 15.

Boss 132. A Raven pecks out the eye of a cat. Vine leaves round the edge.

In the Bestiary, the Raven is credited with always going for the eye of a corpse before attacking the rest of the body.

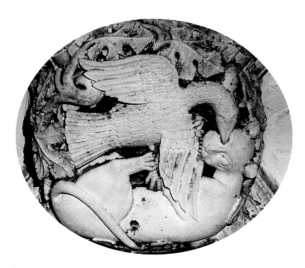

Ravens, because they were black, usually had negative implications. But those stories were given a positive moral twist. It points out that they were seen as a good symbol in the Song of Songs 5 v 11, "His locks are bushy and black as a raven." We know that the Song of Songs was interpreted as Christ's love for the Church, and as the love Mary had for Him. Of more relevance to this particular carving, medieval preachers used the metaphor 'Penance and Confession are like Ravens, for they pull out the eyes of covetousness from the soul that is dead in trespass and sin.'[61]

The 'cat' here is very like the animal in Boss 45. p 55. Round the edge are vine leaves.

Boss 133. The Vine.

We hardly now need reminding of "I am the Vine", and so this is to tell us yet again about Christ.

Boss 134. Maple and maple seeds.

If the vine refers to Christ then maple seems to refer to Mary and the reasons, so far as I have been able to discover, are with Boss 10. p 19.

The next three bosses show a crowned head at Boss 135, then a 'Green Man' still in his original colouring: Boss 136. This is an excellent example of Deity as a Green Man.
Finally a rather dark dragon: Boss 137, who again is biting his wing. Figuratively, he is renewing himself in this holy environment. (p 9 *in Introduction*).

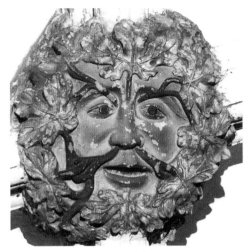

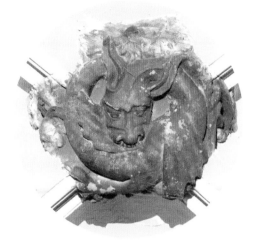

Boss 136 Boss 137

That is now the end of the short processional route, and we should move to the side chapels of the Lady Chapel, where there are a few bosses with significantly different foliage that merit discussion.
In St Gabriel's chapel to the south of the Lady Chapel:-

Boss 31a. Mallow.
The web-site sees this as possibly geranium but there is no doubt about the identification.

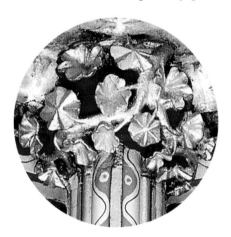

Pliny said that mallow had no noxious properties and was a good preventative against all disease. Then Isidore of Seville (560-636 AD) is quoted as saying that it was good against serpents and bee stings. Because of this it came to signify Salvation.[52]

Mallow was known in France, Germany, Spain and Denmark as St Simeon's plant but quite why is not clear.[18] Simeon was the old man who had been told that he would not die until he had seen the Lord's Christ. Mary takes Jesus to Jerusalem for the ceremony of purification after the birth. Simeon meets them and breaks forth into the Nunc Dimitis. Sung now at evensong, it contains "Mine eyes have seen thy salvation, which thou hast prepared before the face of all people." (Luke 2 v 30-31.) Simeon goes on to foretell the 'fall and rising again of many in Israel'. It is not a surprise to find such a witness in areas associated with the Virgin Mary.

Boss 29a. Probably Ranunculus.

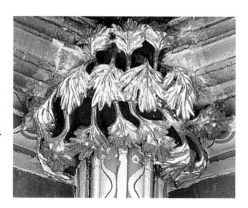

This is Ranunculus or buttercup. It flowers at its best in May, Mary's month, and there was the legend of how the stars, wishing to honour her, came down to earth as the lovely yellow flowers of this plant. See Boss 42, p 54 and Boss 124, p 46.

Boss 32a. A Man's head from which sprouts leaves of Wild Celery.

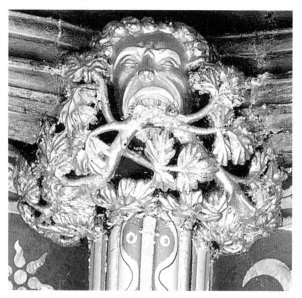

My botanical advisors made this identification.

In antiquity, parsley and celery were confused with each other. Parsley was sacred to the Virgin Mary because it flowered in May.[52]

Of possibly more interest is its Latin name, _Petroselinum,_ because it grew on stones. It was consecrated to St Peter in his character of successor to Chiron. p 33. This cathedral is also consecrated to St Peter. He was the stone on which the Church was founded.

Does this tell us that the deity gives us St Peter and all that meant for the future of the Church? Or, is this St Peter who rejoices in the New Life in paradise? Or is it the papacy charged with speaking the 'Word' in its continuing form?

Boss 32. Maple, hawthorn and hazel.

These three feature together and they appear to be the three plants most closely associated with Mary, her virginity, and the gifts she was instrumental in obtaining for mankind.

The other bosses in this chapel, some of them particularly beautifully carved and gilded, repeat the species that we have already discussed.

The north side chapel of St John the Evangelist also has many foliage forms but again nothing new iconographically.

 The central **boss - 25 -** has a dragon feeding on maple leaves; even the sinner can come to Mary for help and forgiveness.

In the rest of the cathedral the carving becomes increasingly stylised as one moves west: reflecting the later dates for the various stages of construction. The choice of plants remains restricted to a smaller range than those already discussed. There are blackberries and iris that are new.

Boss 215. Iris / *Fleur de Lys*, very stylised in form.

There is an enormous number of potential associations for this flower form, so I can only sketch a brief outline of some of the possibilities.

In ancient Egypt it was the symbol of fecundity and royalty. It was a sacred plant and Tree of Life, adopted by Assyrians and Persians, from where it spread to Teutonic and Latin countries. I noticed the shape prominently displayed on Corinthian capitals in the Forum in Rome.

It is the symbol of France and French royalty, and has been so since the time of King Clovis (5th Century.) He adopted the yellow Flag Iris as an emblem after it helped him to avoid defeat by the Goths. He noted a patch in the middle of a river and correctly deduced that at that point the river would be shallow enough to cross. He was converted to Christianity because his Christian wife had encouraged him to pray for victory and he was not disappointed.[48] The French banner included the iris form by the 14th Century. King Louis VII on the Crusades had used it. It may have been called 'Fleur de Louis', becoming 'Fleur de Luce', and finally 'Fleur de Lys or Lis.'[23] The river Lys in France carries a profusion of them on its banks.

To complicate the etymology but to simplify the iconography, 'Fleur de Lys' is French for 'Lily'. So we move seamlessly from an iris to a lily.

It occurs in the architecture of the Cistercians as the flower of the Virgin. They were known for their lack of decoration but they allowed themselves this flower for she was their patron saint.[37p153] Elizabeth Haig also notes that the noblest use for the Fleur de Lys was to express the majesty of God. [37] Floriated crowns to symbolise the Divine majesty were common in France, Germany and the Netherlands.

In mosaics at Ravenna, where the lily is used for the delights of heaven, they are drawn in silhouette with three petals. There they closely resemble the iris or Fleur de Lys. Both iris and Madonna lily are considered sacred to the Virgin and have been since Ancient times.[48]

The Fleur de Lys is the trefoil shape used extensively in pictures and carvings from the Middle Ages. There is the obvious basic association with the Trinity and with three the number for the deity but also it appears in many other contexts.

F. Garnier lists six great themes where the Fleur de Lys is an integral part of the many illustrations he gives, using examples from many areas. [26 p207-222] As with all powerful symbols, familiarity bred indifference and it gradually lost all significance, becoming merely decoration – inducing here and there a little deference.

Initially he sees it representing two theoretically incompatible states of reality: the natural with the supernatural. All other religious and moral applications derive from this fundamental situation. He classifies them under six headings:

I. *"In the beginning was the Word."*
The Fleur de Lys appears in pictures of: -
Christ in majesty; The Creation of Heaven and earth; Moses becoming Christ's intermediary between Himself and man; St John the evangelist, whose gospel starts with those words above; the Church as the bride of Christ; and Philosophy holding a trefoil-headed sceptre.

II. *The Incarnation.* In Annunciation scenes the angel holds a trefoil-headed sceptre, and of course the lily features in all later paintings.

III. *Redemption.* Abraham's sacrifice of Isaac was seen as prefiguring the New Testament Redemption, and illustrations feature a large Fleur de Lys. The effects of Redemption are illustrated by a martyr making the ultimate sacrifice; as one of the elect he goes to eternal life, with Fleur de Lys prominent in the picture.

IV. *Flower of Divinity.* The episodes in Joseph's story were seen as prefiguring those in Christ's. In commentaries on Genesis Ch. 37, the episode where Joseph dreams while in the fields was held to equate to Christ's sleep in the sepulchre. The sheaves bow down to Jacob's sheaf, an episode paralleled in the picture, where good Christians adore Him with the flowers (Fleur de Lys) of the divinity.

It appears in pictures that highlight and contrast the spiritual v. the material life. In pictures about the application of wisdom, such as those of Solomon, it features as a central comment. It may appear in pictures of the Mass, and in some it acts as the instrument of consecration.

V. *The Science of the Last Things, or Eschatology.* Where Christ is seen in judgement, deciding who shall be among the elect and who shall be damned, the Fleur de Lys belongs to Christ and the elect.

VI. *All Power comes from God.* The Fleur de Lys is a sign associated with both temporal and spiritual power. It appears on the heads of sceptres – that formal emblem of power - and frequently on crowns.

This is but an outline of the examples he gives with associated illustrations, (a total of 33). They provide examples of what the well-furnished medieval mind would find illuminating and enriching.

The centre of this boss delineates a Cross in the negative space. This is an ancient artistic device that adds an extra dimension to this picture. (*Note 2 p 65.*)

Three purple iris in a vase in later Annunciation pictures, where it is usually placed between Mary and the Angel, represents the dogma of the immaculate birth of Christ. The transparent vase typifies Mary in the same way that does the clear glass through which flies the dove of the Holy Ghost on a ray of light at the moment of Incarnation.[37] The glass that was pierced, but not shattered, by the Holy Spirit carries the same significance as the Burning Bush that was touched but not consumed.

Boss 349 and Pulpitum. Blackberries.

There is a very accurate, if broken, blackberry on the SW corner of the Pulpitum. There are bunches of berries and atypical leaves on Boss 349. One of the bosses of the north aisle, Boss 319, also has berries. Such a common plant as the blackberry acquired a host of folklore stories but none that I have seen mentioned seem to tie to the time of the building of the cathedral.[35]

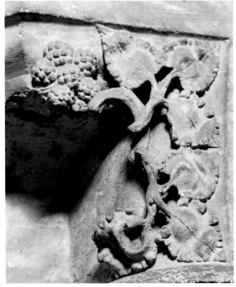

Pulpitum. Blackberries. Boss 349

It features in medieval painting as an example of the Burning Bush from which God appeared to Moses Ex.3 v 2-5; this belief led to it becoming a symbol of Mary's virginity. She bore the flame of divine love without being consumed by lust, just as the bush survives the presence of God. By extension it also became a symbol of the Immaculate Conception; for in the flames of original sin, Mary preserved her purity of body and mind.[52]

For Paul it was a symbol of the major sins. Heb.16 v 8. "that which beareth thorns and berries is rejected and is nigh unto cursing; whose end is to be burned."

It has been seen as a symbol of the Passion because it had been used for the Crown of Thorns.

In Luke 6 v 44 "For every tree is known by his own fruit. For of thorns men do not gather figs, nor of a bramble bush gather grapes."

The cathedral contains many examples of 'positive' ideas associated with Mary, and I suspect that the association with her Virginity is the intended message.

Summary.

If there is one idea built into the flowers and leaves it is that of exuberant life. Dead stems just do not occur except to denote the Old Law, and that only rarely. Christianity is all about a new Life, if not physically in this world, then certainly in the next. The spiritual life though, has to start in this world, and the designs given such dramatic form at Exeter are there, at least in part, to light the path.

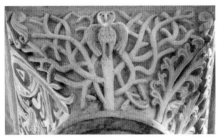

Senlis. An Owl in bare branches. Metaphorically the sterile Old Law.

Even the least devout would have appreciated the reminder of Mary, the Christ Child and Living Water as promised by the maple. Mary's virginity and Christ's Passion, everywhere described by hawthorn or May, lighten the daily burden of toil. I suspect that only the literate and the clergy would have enjoyed the connection between mandrake (white bryony) and the story of Rachel and Leah. For them it could be savoured as one of those 'sweetest things'.

Some plants that one might expect to find are not there. *Alchemilla mollis* or Lady's mantle, *Cardamine pratensis* or Lady's smock, *Clematis vitalba* or Virgin's bower, do not appear here nor elsewhere though I cannot vouch for that.

Holly, Palms, Pinecones joined later by Pomegranates and others do have an iconographic story and are used elsewhere to create a rich resource for the carver and patron.

While it is tempting to visit Exeter and to learn about Exeter as a unique place, it should be remembered that all Christendom was striving to present the Faith in a new and, to thcm, cxciting fashion. New ideas, or at least old ideas in new clothes, came from the great thinkers of the time. To give the ideas a physical presence the artists had to develop new codes of expression. They could not be entirely new, or they would not be understood. They had to hark back to the older ways, while at the same time showing that they were at the cutting edge of the developing iconography. The resulting differences between cathedrals, including those of Northern France and Germany, are relatively small. The ideas, and folio of ideas, for each place are very similar. We are fortunate in being able to enjoy such work undamaged for over seven hundred years.

The cathedral contains a wealth of other carvings of people, faces and animals, all pointing to various aspects of the moral and spiritual life. Others are memorials to Kings and Queens or historical episodes such as the murder of Thomas Becket, one of the great scandals of Christendom of the time. To concentrate attention only on them and ignore the foliage, is to miss what might be termed the background music. My hope is that one will now be able to enjoy more fully this hitherto ignored aspect of decoration in a church or cathedral.

Note 1. The equivalence between white bryony and mandrake is not just an Exeter or even English phenomenon. It was well known in Germany. There, several plant roots stood in for mandrake in the 'con-man's' armoury. They were white bryony, German flag - or blue iris, and yellow gentian. The connection to the episode of Rachel and Leah is also well known. [7]
p 136, 8

Note 2. I owe this to Rita Wood, in York, who also provides a scholarly exposition of the Green Man.[75]

Note 3. Celia Fisher of [23] pointed out to me that in Virgil's Georgics there was a proverb, 'that snakes liked to hide under strawberry leaves and that small boys should be careful when picking the fruit'. Apart from boosting the egos of the Latin scholars, this would tie in with the dangers of picking tempting fruit that has echoes in the Garden of Eden story.

Carvings mentioned in the text but not directly part of this study.

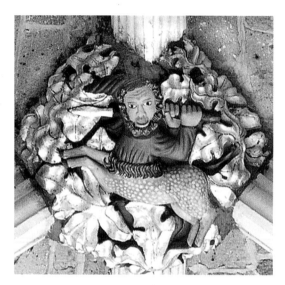

Boss 211
A "Good" Centaur.

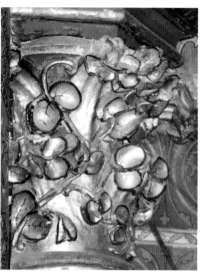

Ste Chapelle. Paris.
Peas.

Boss 174

The central boss of the
whole cathedral.

The Christian Knight
takes on the three foes:
the World, the Flesh
and
the Devil

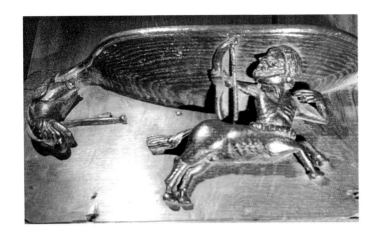

Exeter

Misericord

A Centaur fires an arrow
at an evil 'dragon'.

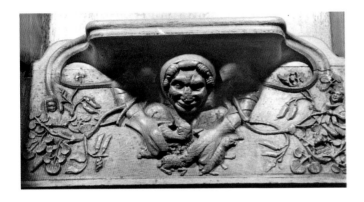

New College
Oxford.

Jack the giant killer.
Note the peas instead of
our version with beans.
The sheep represent us.
The Giant has deformed
hands in his gloves.

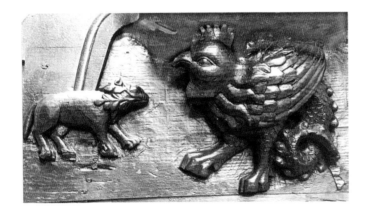

Re Boss 37a.

A Weasel carries some
Rue to ward off the lethal
glance of the Basilisk
or "Cockatrice".

Misericord
Worcester Cathtedral.

BIBLIOGRAPHY AND REFERENCES

1 Alexander, J. Ed. *Age of Chivalry*. Introduction. Catalogue. Royal Acad. of Arts. Weidenfeld & Nicolson. London. 1987

2 Anderson, M.D. *Drama and Imagery in English medieval churches*. CUP. 1963.

3 Anderson, M.D. *History and Imagery in British Churches*. John Murray 1971.

4 Barber, R. *Bestiary. Being an English version of the Bodleian Library, Oxford*, M.S.764. Folio Soc. 1992

5 Basford, Kathleen. *The Green Man*. Ipswich. 1978

6 Beigbeder, O. *Lexique des Symboles*. Zodiaque. 1989.

7 Behling, Lottlisa. *Die Pflanze in der Mittelaltichen Tafelmalerei*. Herman Bohlau. Weimar. 1957

8 Behling, Lottlisa. *Die Pflanzenwelt der Mittelalterlichen Kathedralen*. Bohlau Verlag. Koln. 1964.

9 Camille, M. *Image on the Edge*. The margins of medieval art. Reaktion Books. London. 1992.

10 Camille, M. *Mirror in Parchment*. The Luttrell Psalter and the making of Medieval England. Reaktion Books. 1998.

11 Camille, M. *Gothic Art*. Everyman Art Library. Orion Publications. 1996

12 Camille, M. *At the Edge of the Law in England in the 14th Century*. Proc. Harlaxton Symposium III. 1991. Paul Watkins. Stamford. 1993.

13 Carruthers, Mary. *The Book of Memory*. A study of memory in Medieval Culture. CUP. 1990.

14 Cave, C.J.P. *Medieval Carvings in Exeter Cathedral*. King Penguin. 1953.

15 Clanchy, M.T. *From Memory to Written Record*. England 1066-1307. Blackwell. 1993.

16 Collins, Minta. *Medieval Herbals. The Illustrative Traditions*. British Library. 2000.

17 Culpeper, N. *Complete Herbal and English Physician*. Manchester. 1826

18 Dowling, Alfred. E.P.R. *The Flora of the Sacred Nativity*. London. Kegan Paul. 1900.

19 Duffy, Eamon. *Stripping of the Altars*. Traditional religion in England. 1400-1580. Yale Univ. Press. 1992.

20 Encyclopaedia Britannica. On a CD edition. 2002.

21 Ferguson, G. *Signs and Symbols in Christian Art*. OUP. 1954.

22 Firth, R. *Symbols public and private*. George Allen and Unwin. 1973

23 Fisher, Celia. "*A study of the plants and flowers in the Wilton Diptych*"; in 'A Royal Image of Richard II and the Wilton Diptych'. Ed. Dillian Gordon et al. Harvey Miller. 1997.

24 Foster, R. *Patterns of Thought*. The Hidden meaning of the Westminster Pavement. Jonathan Cape.1991.

25 Gardner, S. *English Gothic Foliage Sculpture*. CUP. 1927.

26 Garnier, Francois. *Le Langage de L'Image au Moyen Age. II*. Grammaire des Gestes. Le Leopard D'Or. 1989.

27 Gerarde, John. *The Herbal or General History of Plants*. London. 1633.

28 Gill, G.G. *Handbook of Symbols in Christian Art*. Cassell. London. 1975.

29 Givens, J. *Medieval Gardens. In 'The garden outside the walls.'* Dumbarton Oaks Research Literature. Washington DC. 1986.

30 Goody, Jack. *The Culture of Flowers*. CUP. 1993.

31 Gordon, Lesley. *Green Magic*. Ebury Press. 1977.

32 Gray, Douglas. *Themes and Images in the Medieval English Religious Lyric*. Routledge & Kegan Paul. 1978.

33 Greene, R.L. *A Selection of English Carols*. Oxford. 1962

34 Grieve, Mrs M. *A Modern Herbal*. Jonathan Cape. 1931.

35 Grigson, G. *The Englishman's Flora*. Phoenix House. London. 1955.

36 Grossinger, C. *The World Upside-Down*. English Misericords. Harvey Miller. 1997.

37 Haig, Elizabeth. *Floral Symbolism of the Great Masters*. Kegan Paul. London. 1913.

38 Harvey, John. *Medieval Gardens*. Batsford. 1981.

39 Henry, Avril. & Hulbert, Anna. *http//exetercathedral.tell-com/*.

40 Herolt, Johannes. *Miracles of the Blessed Virgin*. Routledge & Kegan Paul. London. 1928.

41 Hopper, V. F. *Medieval Number Symbolism*. N.Y. 1938 & 1969

42 Hunt, Tony. *Plant Names of Medieval England*. Boydell & Brewer. 1989.

43 Jalabert, Denise. *Le Flore Sculptée des Monuments au Moyen Age en France*. Paris. 1965.

44 James, M.R. *The Apocryphal New Testament*. Oxford 1924 & 1963.

45 Jameson, A.B. *Legends of the Madonna*. London. 1899.

46 Joret, C. *Les Plantes dans L'Antiquité et du Moyen Age*. Vol. I & II. Paris. 1897.

47 Kraus, Henry. *The Living Theatre of Medieval Art*. Thames & Hudson. 1967.

48 Krymow, Vincenzina. *Mary's Flowers*. St Anthony Messenger Press. Cincinnati. Ohio.1999.

49 Mabey, R. *Flora Britannica*. Chatto & Windus. 1997.

50 Maccoll, D.S. *Grania in Church; or the Clever Daughter*. Burlington Magazine. 8. 1905. Pp 80-86.

51 Mâle, E. *The Gothic Image. Religious Art in France in the Thirteenth Century*. Icon Edition. 1972.

52 Mirella Levi D'Ancona. *The Garden of the Renaissance*. Botanical Symbolism in Italian Painting. Firenze. 1976

53 Mirella Levi D'Ancona. *The Iconography of the Immaculate Conception in the Middle Ages and Early Renaissance*. Art Assoc. of America with Art Bulletin. 1957

54 Morgan, Nigel. *Text & Images of Marian Devotion in 13th Century England*. Harlaxton Medieval Studies I. Proceedings of the 1989 Harlaxton Symposium. Ed. W.M.Ormrod. Paul Watkins. Stamford. 1991.

55 Morgan, Nigel. *Text & Images of Marian Devotion in 14th Century England*. Harlaxton Medieval Studies III. Proceedings of the 1991 Harlaxton Symposium. Ed. Nicholas Rogers. Paul Watkins. Stamford. 1993.

56 Morgan, Nigel. *Early Gothic Manuscripts*. I & II 1190- 1250 & 1250-1285. Of a Survey of Manuscripts Illuminated in British Isles. Harvey Miller & OUP. 1988.

57 Morris, M.G. & Perry, F.H. Eds. *The British Oak*. For Botanical Soc. of British Isles by E.W.Classey Ltd. 1974.

58 Morris, D. et al. *Gestures their origins and distribution*. Jonathan Cape. London. 1979

59 Neaman, Judith S. *Magnification as metaphor*; in Harlaxton Medieval Studies. I. Proceedings of the 1989 Harlaxton Symposium. Ed. W.M.Ormrod. Paul Watkins. Stamford. 1991.

60 Ormrod, William. *State Building and State Finance in reign of Edward I.* in Harlaxton Medieval Studies. I. Proceedings of the 1989 Harlaxton Symposium. Ed. W.M.Ormrod. Paul Watkins. Stamford. 1991.

61 Owst, G.R. *Literature and Pulpit in Medieval England.* Oxf. 1961.

62 Pevsner, Nikolaus. *The Leaves of Southwell.* King Penguin. London & New York. 1945.

63 Prideaux, E. K. & Holt Shafto, G.R. *Bosses & Corbels of Exeter Cathedral.* 1912.

64 Randall, Lilian. *Images in the Margins of Gothic Manuscripts.* California Univ. Press. 1966.

65 Sandler, Lucy Freeman. *Gothic manuscripts. 1285 – 1385.* I. Text and Illustrations. Harvey Miller. 1986.

66 Seward, Charles. *The Foliage, Flowers and Fruit of Southwell Chapter House.* Cambridge Antiq. Soc. Communications. Vol. XXXV 1935.

67 Straten, Roelof von. *An Introduction to Iconography.* Trans. by Patricia de Man. Gordon & Breach. 1985 & 1991.

68 Swanton, M. *Roof Bosses and Corbels of Exeter cathedral.* Exeter Cathedral 1979.

69 Tisdall, M.W. *God's Beasts.* Charlesfort Press. 1998.

70 Voragine, Jacobus de. *The Golden Legend.* 2 Vols. Princeton Univ. Press. 1993.

71 Walker, Winifred. *All the Plants of the Bible.* Lutterworth Press. 1958.

72 Warner, Marina. *The Myth and Cult of the Virgin Mary.* 1976 & 2000. Random House.

73 Winston Allen, Anne. *Stories of the Rose.* The Making of the Rosary in the Middle Ages. Pennsylvania State University Press. 1997.

74 White, T.H. *The Bestiary.* A translation from a Latin Bestiary of the 12th Cent. Jonathan Cape 1954.

75 Wood, Rita. *Before the Green Man .* Medieval Life. 14. Autumn 2000. pp8-13.

76 Woolf, R. *The English Religious Lyric in the Middle Ages.* Oxford. 1968

77 Zohary, M. *Plants of the Bible.* CUP. 1982.

INDEX

Aesculapius33
Annunciation..................5, 19,63
Apocryphal gospels...9,10, 22,69
Artemisia.............4,6, 25, 29, 32,
...................33,34, 35,46, 53,54
Aspidochelone28
Bay tree22
Beech52
Bestiary7, 9, 27,28, 36,48,
............49,51,52,53,57,58,68,70
Birch....................................25
Birds feeding....................41, 51
Blackberry.........................49,64
Bluebell............................13,14
Broom pods.................35,36, 56
Buttercup.................46, 54, 60
Cat....................................55,58
Caterpillars.................19, 49, 52
Celery...................................60
Centaur.......................33, 66,67
Chartres5
Chelidonium majus48
Chiron, the centaur.........4,33,34
Comfrey25
Coronation of the Virgin
.............................6, 32, 36
Cow suckling her calf28
Dionysus27
Dittany53
Dodona.................................18
Dog....................................23,45
Dragon6, 9, 33, 46, 47,
.........................49,51, 59, 61,67
Eagle6,7,13,14
Fig17,20,42,43,45,61,64
Fish....................................28,29,44
Fleur de Lys62,63
Flight into Egypt19,20,21,38
Fox7,28,29, 55
Freiburg im Breisgau35
Gemini45
Gideon..................................19
Goats.......................27, 52,53
Golden Rose...................2,15,16
Greater Celandine48
Green Man14,40,53,59, 65
Hare......................7,14,41, 45
Harebells13,14
Harrowing of Hell10
Hawthorn7,19,20.38,40,
.........................41,46,51,61,65

Hazel25, 38, 39,40,51,61
Headdresses28
Herb of Grace.......................47
Herb Paris54
Herba Trinitatis41
Hildegard v. Bingen10,21,
............................25,26
Hop.......................7,35,36,56
Humility36
Hyacinths13,14
Immac. Conception..........10, 22,
................................64,69
Incarnation6,19,36,39,41,63
Iris61,62,65
Isidore of Seville..........10, 21,59
Ivy6, 7, 19, 27, 37, 51
Jack and the beanstalk............50
Jacob23,24,63
Jew25,40,43,56
Joseph............0,24..,25,28,39,63
Jesse17,25,35
Leah24,25,65
Lungwort........................8,25,26
Luttrell Psalter............45, 54,68
Mallow59,60
Mandrake23,24,25,65
Maple7,19,20,21,55,56,58,
............................61,65
Marcolf..................41,42
Mary and Martha25
Mater Herbarum...............33, 34
May38, 40, 41,46,60, 65
Mary.......2,5,6,7,9-11,13,14, 15,
.....16-22,25-28,30,33-36,38-41,
............43,46,50,52,54-61,63-65
Mermaid.............................43,44
Mortmain42
Mugwort.................6,26,32,33
Mulberry7,26
Naumburg25,26,30
New Coll. Oxf..................50,67
Notre Dame, Paris................5,6
Number6,55,62,69
Nuts................19,38, 39, 51,52
Oak.........6,7,18,19,30,37,39,46,
............................47,52
Oak galls19
Parsley................................60
Pears55,56
Peas50,66,67
Petroselinum60

Pig46,52,56
Plan of Cathedral12,31
Plane......................19,21,26
Planta Genista36
Preen9, 51
Puns..............8, 9,36,39,50
Rachel24,25,65
Ranunculus.............46,54,60
Raven58
Rebus8
Reims6, 22, 25
Riddle....................................41
Rosa Mystica....................15,16
Rose2,6,14,15,16,21,35
............................50,57
Rose of Sharon......................15
Rosary16,40
Rue47,48,67
Samson.................................10
Serpent49,59
Signatures, Doctrine of;8
Siren43,44
Snake.....................................49
Sow suckling her piglets45
Squirrels........................39, 51
St Brannock...........................46
St Frideswide's tomb20,23,48
St Gregory........................6, 15
St John...............13,14,38,61,63
St John's eve33
St Peter...........................13,60
St Simeon...........................60
Stone thrower44,45
Swallow48
Sycomore/Sycamore19
............................20,21,26
Thistle30
'Tudor' rose...........................16
Tree of Life18,20,27,43
............................53,62
Vine.................6,7,17,18,25,28,
............................35,37,56,58
Virgin Immaculate15
Vulture57
Water19,20,21,26,43,65
Weasel.........................48,67
Well of Living Water..............20
White Bryony...........7,13,23,25
............................37,65
Wisdom26,14
Wrestlers44,45